SOUTHERN OREGON
TIMBER

Published by The History Press
Charleston, SC 29403
www.historypress.net

Copyright © 2015 by R.J. Guyer
All rights reserved

Front cover: Photos courtesy of the Douglas County Museum.
Back cover, bottom: Photo courtesy of Allyn Ford.

First published 2015

Manufactured in the United States

ISBN 978.1.62619.944.6

Library of Congress Control Number: 2015941626

Notice: The information in this book is true and complete to the best of our knowledge. It is offered without guarantee on the part of the author or The History Press. The author and The History Press disclaim all liability in connection with the use of this book.

All rights reserved. No part of this book may be reproduced or transmitted in any form whatsoever without prior written permission from the publisher except in the case of brief quotations embodied in critical articles and reviews.

SOUTHERN OREGON TIMBER

The Kenneth Ford Family Legacy

R.J. GUYER

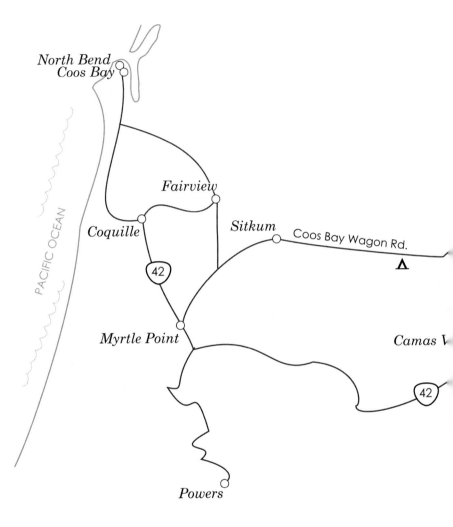

Map of southern Oregon. *Created by Amy Goodwin.*

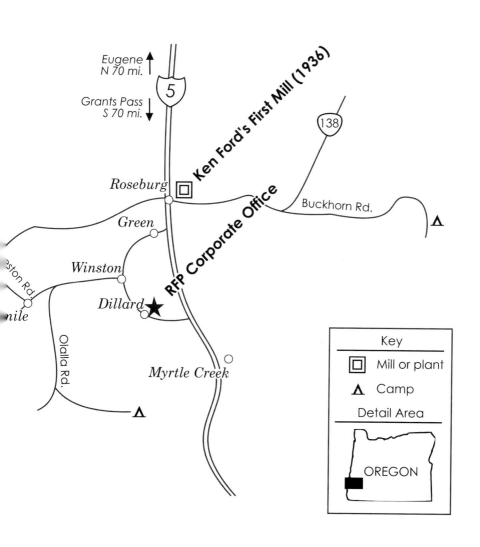

For Donna Watkins, my friend and researcher extraordinaire.

CONTENTS

Foreword, by Donna Watkins 11
Acknowledgements 15
The Loggers, by Nelson Reed 17
Introduction 19

1. Early Timber Cruising 21
2. Of Mills and Men 34
3. A Balancing Act 47
4. Willamette Valley 54
5. Sawdust in the Veins 59
6. Bucking the Trend in Roseburg 70
7. World War II 86
8. Postwar Booms and Expansion 94
9. Plying His Trade 107
10. Cutting Edge 117
11. Run of the Mill 124
12. Out on a Limb 132
13. Transitioning 138
14. A Firm Foundation 145
15. Sustainable Yields 151

Bibliography 153
Index 157
About the Author 159

FOREWORD

Thirty years ago, if asked who Kenneth Ford was, most Douglas County residents would have replied that he was the owner and founder of Roseburg Lumber: "Pappy Ford" the lumberman. Today, the answer might be different and his legacy measured by something more valuable than one billion board feet of lumber.

Having grown up in Roseburg, I, like most people in my community, knew of Mr. Ford. Because Roseburg Lumber was the major production company in Douglas County during the 1950s, '60s and '70s, a large number of small businesses thrived by providing services or products needed by the company. My husband's family owned a local radiator shop; a fair share of its business consisted of repairing or replacing radiators for the Caterpillar shop and the logging trucks. My father owned the local shoe repair shop. The loggers provided a steady flow of traffic to his store because they were in constant need of having their caulk boots refurbished.

In the late 1970s, I became aware of generous donations provided periodically by an "anonymous" donor. It didn't take long to determine that Kenneth Ford was ensuring that kids in the community would not go to school without decent shoes and warm coats. As our world moved forward into higher technology, he likewise provided computer labs and drafting technology for all county schools. These are but a few examples of Mr. Ford's generosity—always making certain that "his people's" basic needs were met.

FOREWORD

Bonnie Ford and I became good friends through our mutual love of serving our community. We worked together on many projects through a Roseburg service club, and our friendship matured. It was because of this relationship that I later met her husband, Kenneth Ford.

When I first met Kenneth, I thought that he was very reserved. It didn't take long to realize that his quiet demeanor allowed him to sit back and gather information—all the time making qualified analyses and formulating questions. He could ask more questions than anyone I had ever met. Oh, there were constant questions!

I once read of someone described as having the "methodology of a Marine and the drive of the Energizer Bunny." That description certainly fit Kenneth. By most accounts, he is known for and distinguished by his dedication to the timber industry. His unwavering adeptness for building for the future and modifying for change in the industry kept him on the leading edge of that industry for more than sixty years. He did more for his industry, more for the local economy and more for local education than any other person in the state of Oregon.

This adventure of writing began in 1994 in a conversation with the Fords. It was clear to me that no one was documenting the "Kenneth stories," and I feared that they would fade under the dust of time. So, I collected stories, conducted interviews, gathered photos and researched the regional newspapers and Internet for related timber and production history for many years. Upon completion of my first chapter, I presented it to Kenneth in 1996. He made no comment, positive or negative, as the project was not completed.

When Kenneth passed away in 1997, I received that first chapter back from Bonnie with notations made in areas where I had documented inquiries for Kenneth to complete. At that point, I boxed up all the research materials and stored them away in the garage because, in reality, the book was going to be for the benefit of Kenneth and his family.

Over the years, through the urging and assistance of a number of people, especially Bonnie Ford, Ron and Cynthia Parker and Jerry Bruce, I kept bringing the material out of storage, reviewing it and conducting more interviews. This I did numerous times, which explains the twenty-year duration of the project.

Writing a story about the life of Kenneth and the Ford family has become my passion. All of this research has been done in the spirit of love and respect for the time, dedication and funding that Kenneth invested in our communities and the lives of so many.

FOREWORD

In this pursuit, I discovered that I am a better researcher than writer. By chance, I was introduced to a local freelance writer, R.J. Guyer, who was intrigued with taking on this project. He joined my endeavor as a fellow researcher but, more importantly, as the writer of this book. Mr. Guyer and I continued the research for another year. And as a result of all that research, here we have finally produced a book!

<div align="right">DONNA WATKINS</div>

ACKNOWLEDGEMENTS

Special thanks to:

Donna and Rick Watkins for your help in researching and making this project a reality.

Fellow author and historian Larry Moulton for your support and countless hours of research on this project.

Art Adams for an educational tour of the Nordic Veneer Plant.

Gardner Chappell, Karen Bratton, James Davis and Richard McQuillan for your support of facts and images for the book.

Dona Townsend for being our liaison and tour guide in the Lacomb area.

The Kleinschmit family for sharing valuable insights on the Ford mills in the Lacomb area.

Allyn and Carmen Ford for your support in making this book a reality and to your extended families for graciously providing your unique and individual perspectives on Kenneth and Hallie Ford.

Anne Kubisch and the Ford Family Foundation staff for timely interviews and your help in securing research materials for use in the book.

Present and former employees, spouses, families and friends of Roseburg Forest Products.

Stephen Hall, Bill Randles and Dave Lowry for facilitating an informative tour of the Engineered Wood Products plant in Riddle.

Phil Adams for guiding us on an educational tour of the Mount Scott timberlands.

ACKNOWLEDGEMENTS

Amy Goodwin for your exemplary work on the maps.

B.J. Bassett, my writing instructor, who encouraged me to step out of my comfort zone and be a writer.

My wife, Ann Caldwell, for proofreading and editing the material and your unyielding support of this project.

Rick Zenn for sharing your insights on the industry and recommendations for research and the grand tour of the World Forestry Center.

Geoffrey B. Wexler for providing us with relevant research material and oral historical interviews from the Oregon Historical Society.

Craig Reed and Vicki Menard. It has been a pleasure to write for the *News Review* over the years.

Fellow author Susan Waddle for sharing your extensive knowledge and images of West Fork, Oregon, and the surrounding areas.

The Pioneer Indian Museum of Canyonville for your continued support of my historical projects.

Candice Lawrence, acquisitions editor at The History Press, for your guidance in writing and publishing this book.

John Robertson of the Douglas County Historical Society.

Jim Marr, Romey Ware and John and Sue Hatfield.

THE LOGGERS

*Oh stranger, ponder well, what breed of men were
these cruisers, fallers, skinners—ox, horse and "cat"—
chokesetters and the rest who used these tools.
No summer's searing dust could parch their souls,
nor bitter breath of winter chill their hearts.
'Twas never said "they worked for pay alone,"
tho it was good and always freely spent.
Tough jobs to lick they welcomed with each day,
"we'll bury that old mill in logs," their boast.
Such men as they have made this country great,
beyond the grasp of smaller, meaner men.
Pray God, oh stranger, others yet be born worthy
as they to wear a logger's boots!*

—Nelson Reed

INTRODUCTION

Logging began in America with the first settlers in the eastern United States. In Maine, it was once declared that the vast stands of timber would last until hell froze one foot thick. A mere half century later, loggers were heading west to fell timber in places like Michigan, Minnesota and Wisconsin. By the nineteenth century, they were looking farther westward to feed their mills.

Early cities in the Pacific Northwest were directly linked to sawmills. Henry Yesler built Seattle's first major sawmill in 1851. As the logs were skidded down a hill to his sawmill, a new logging term was created: "Skid Road." Today, that "Skid Road" is a street known as Yesler Way.

The advent of logging timber in southern Oregon came about when the Native Americans used the local timber to sustain their basic needs. They built wooden homes known as lodges for shelter in the winter, when the traditional canvas teepee would not suffice. They also found that red cedar worked well for dugout canoes, which aided them in transportation and fishing.

Early timber mills were established in Gardiner and Coos Bay, conveniently located along the shipping routes on the coast. At the same time, scores of immigrants had arrived via the Oregon Trail. As the population grew, so too did the size and dynamics of the mills as they worked to keep up with the increased demands and uses for lumber. In 1850, over fifty thousand people worked in logging, making it the second largest industry in the United States.

The completion of the railroads opened up the inland sections of the region with an efficient mode to deliver timber to markets throughout the country.

INTRODUCTION

This also created additional competition for timberlands as an influx of established lumber companies from the eastern and midwestern United States began to expand their influence and operations in the Pacific Northwest.

However, logging in the Pacific Northwest was much different than what they had back east. The trees were far larger and heftier than anything they'd encountered. At this time, loggers were tasked with cutting and transporting old-growth timber and redwoods. These big trees grew in much more rugged terrain consisting of deep canyons and steep slopes. This created great challenges that tested the ingenuity and perseverance of the western logger. A new breed of rivermen acquired skills in utilizing splash dams and taming the rapids.

By 1909, over half a million people were employed in timber-related jobs in America. The tall tales and exploits of Paul Bunyan added to the country's fascination with logging. These tales were initially told around lumber camps and campfires years before they were published. Authors Esther Shephard and James Stevens both released collections of these and other sensationalized stories in the 1920s.

This book chronicles the history of the timber industry in southern Oregon and the story of Kenneth and Hallie Ford, who in 1936, during the heart of the Great Depression, established a small sawmill in Roseburg, Oregon. Their story is about the spirit and determination needed to overcome obstacles and build one of the largest family-owned timber enterprises in America. Their legacy lives on today through their philanthropic endeavors, including the Ford Family Foundation.

1
EARLY TIMBER CRUISING

On the heels of the successful Lewis and Clark expedition came a rush of fur trappers and traders who sought to make their fortunes in the newly opened Pacific Northwest Territory. The plentiful furs in this untapped area caught the eye of fur trapper John Jacob Aster, who felled trees in establishing a post in the territory in 1811. Soon thereafter came the Hudson's Bay Company. John McLoughlin, chief factor of the company, earned the title "Father of the Pacific Coast Lumber Industry" when he established the first "official" sawmill in Oregon in 1827. The purpose of the mill was primarily to cut lumber to build Fort Vancouver and other outposts needed to promote their trading operations.

LAND ROVERS

"Manifest Destiny" became a popular term during the nineteenth century. It encouraged people to stretch out from coast to coast in the United States. This fueled large-scale western migration beginning in 1843, when about eight hundred people arrived in the Pacific Northwest via the Oregon Trail. The Donation Land Claim Act of 1850 stimulated even more community development.

Settlers arrived in droves to claim their stakes, with the opportunity for a new start in the untamed territory. Villages were sprouting up across the

region, creating a demand for lumber. Timber was a plentiful commodity for use in building, and small mills worked frantically to keep up with expansion. Many mills were portable and could be moved from site to site as needed.

Moses Dyer had one of the first permanent sawmills in the Umpqua watershed on his donation land claim. This unique water-powered mill was built on South Myrtle Creek. Author Stephen Dow Beckham explains, "The saw was driven by a waterwheel geared through a turbine. The saw cut only on its downstroke, while the mill operator inched the log forward for another cut." It was a slow process but cut "superior" flooring for cabins.

On January 24, 1848, gold was discovered in the American River near Sutter's Mill, California. It triggered the Gold Rush as prospectors began to spread outward in search of wealth. By 1852, gold was discovered near Coffee Creek in southern Oregon.

In addition to this frenzy was the arrival of the railroads. In 1866, the Oregon and California Railroad Company (O&C) was granted 3.7 million acres of timberland by the federal government for construction of a railroad in western Oregon. The land was granted in a checkerboard pattern with alternating square-mile sections divided between the railroad and government. The sawmills were humming along the railroad route to provide railroad ties. The track also brought more commerce into the region, which added to the local economies.

East Meets West

This westward progression was fueled by several land grant opportunities in Oregon. The Timber Culture Act of 1873 granted homesteaders up to 160 acres of land if they agreed to plant at least forty acres of trees on the property. The Timber and Stone Act of 1878 was designed for logging and/or mining land that was deemed unfit for farming. After the Donation Land Claim Act of 1850 expired, there would come a National Homestead Act and the Oregon Territorial Act of 1848, along with the Oregon Statehood Admission Act of 1859. These acts were designed to support education and bring in revenue for schools.

Loopholes in applications for these programs were quickly exploited and created quite a circus between large timber operators with deep pockets and a new form of land sharks. It was commonplace for one person to file two claims for 160 acres. Under the Timber and Stone Act, land could be

bought for $2.50 per acre. Acreage from the school-grant lands was sold for as little as $1.25 per acre. Because of the loopholes that allowed financial gain by companies and individuals, the acts would become known as the "School Land Ring."

Speculators would file the claims and put them up for bid to out-of-state timber companies, while others were hired directly by the companies to obtain the land. This resulted in literally hundreds of men entering the forest to file timber claims. For the Timber and Stone Act, the United States government merely required a power of attorney for making the land purchase. Since the certificates were accompanied with a blank assignment, the purchasers or speculators could assign the land to whomever they chose. Thus, each person could file multiple applications. While taking advantage of these loopholes might be debated ethically, the practice was within the confines of the law.

Sea Worthy

Asa Simpson was born in Maine and learned shipbuilding from his father there. He was an apprentice shipbuilder when gold fever struck him. He sailed his ship around Cape Horn to the California gold fields in 1850. After a short stint in mining, Simpson had amassed several pounds of gold, but he decided his fortunes lay elsewhere. After opening a retail lumberyard in Stockton, California, he sailed the Oregon coast in search of additional sources of timber. The next year, he purchased a partially built mill in Astoria. Further exploration of the coastline led him to Coos Bay, Oregon.

By 1856, he had established a sawmill in North Bend, taking advantage of the prime virgin timber in the area. However, as a small mill owner, he felt he was at the mercy of the shipping companies. Simpson took matters into his own hands and put his former training as a shipbuilder into practice. He established the Coos Bay Shipbuilding Company with master shipbuilder John W. Kruse. By 1859, his 103-foot brig, *Arago*, was launched from what would become the shipbuilding capital of the world.

In his further pursuit of timber, Simpson later bought a controlling interest in the Gardiner Mill Company. His shipbuilding partner John Kruse had been a founding partner in that mill, which had its own fleet of sailing vessels. The schooner *San Gabriel* (a steamer) was joined by several (two-, three- and four-mast) ships along with tugboats used to escort ships over the

SOUTHERN OREGON TIMBER

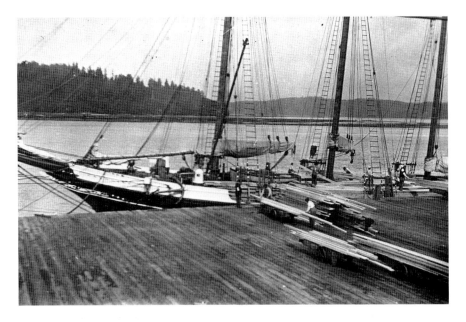

Loading Asa Simpson's ship at Gardiner mill. *Photo courtesy of the Douglas County Museum.*

hazardous Umpqua Bar. Simpson would also acquire mills in Port Orford, Oregon, and Crescent City, California, as well as in Washington State.

Another shipping magnate, Robert Dollar, would become heavily invested in the timber industry. He acquired mills in many logging settlements across southern Oregon and in the redwoods of northern California. Dollar was making his own living at age eleven as a shore boy at a lumber camp in Canada. From childhood on, Dollar adhered to a set of four rules: do not cheat, do not be lazy, do not abuse and do not drink. He credited his success to following these guidelines.

Like Simpson, Dollar amassed a fortune in combining both timber and shipping. The Dollar Steamship Line in the Pacific provided cargo ships that opened the supply route for lumber to Asia. His ships stood out across the world with his trademark "$" insignia on the smokestack.

Later in life, Dollar summarized his career:

> *I started life as a woodsman. I soon learned that in order to succeed a man must know more than one thing thoroughly. Many years have passed since I started looking away from the woods to the source of demand in the world markets. I found plenty of sale for my lumber and built up a steamship company as well. I knew that if I had only concerned myself with the*

THE KENNETH FORD FAMILY LEGACY

cutting of trees and not the ultimate sale of those trees, I would never have advanced far....As the years advanced, and I got deeper into the old problem of supply and demand, my business just naturally grew and I found myself, though still a lumberman, a ship owner as well.

Known as the "Grand Old Man of the Pacific," even *Time* magazine paid tribute to Dollar's successful career by placing him on the cover of their March 19, 1928 magazine. His was truly an exemplary "rags to riches" success story. He died in 1932 at the age of eighty-eight. At that time, his estate was estimated at $40 million.

MOVING THE TIMBER

The practice of logging has changed dramatically over the years. The early timber men employed a great deal of ingenuity in their methods and techniques for cutting timber and securely moving it onward to the mills for processing. The varied and often rugged terrain of southern Oregon made for a plethora of unique challenges. This was especially true given the basic tools at their disposal, often in the remote reaches of the woods.

Eventually, through trial and error, loggers became more proficient, and their expertise would lead to improved technology and safety. Roads were carved out in short order to access timber stands as Caterpillars and bulldozers replaced oxen and horse teams in the forests. The invention of the steam donkey revolutionized the industry for more efficient hauling and loading (yarding) of logs. This replaced the skid roads as loggers would "road" the logs from one steam donkey to the next over long distances that once required moving animals back and forth with much more effort exerted by both man and beast.

According to author A.S. Gintzler, safety became a major concern, as at least 7,500 loggers died between 1870 and 1910. A spar tree was replaced by a steel spar, eliminating the high climbers and riggers. In early logging, after an adequate landing area was found to assemble the cut logs, a tall, straight tree was selected nearby. The high climber then ascended the tree, cutting off branches along the way up. He would then cut off the top portion of the tree to attach the rigging cables and chokers used to pull the cut logs into the landing area. The rigging and high climbing positions were arguably the most dangerous jobs in logging. The high climber risked being blown or thrown off the tops of violently swaying trees.

SOUTHERN OREGON TIMBER

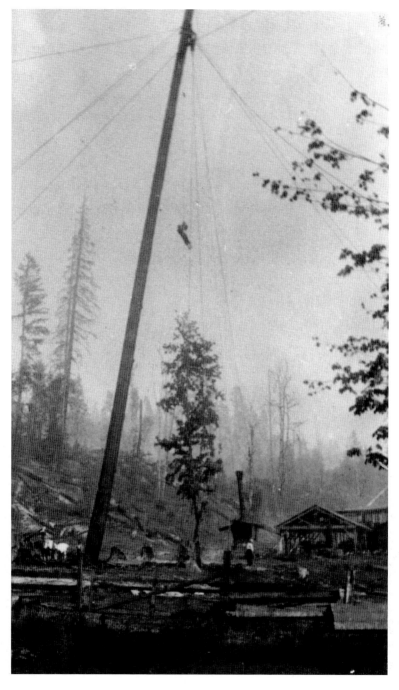

A high climber on a spar tree, Lacomb mill, 1929. *Photo courtesy of Allyn Ford.*

THE KENNETH FORD FAMILY LEGACY

Chainsaws greatly decreased the labor of cutting; perhaps the addition of hardhats was the biggest factor in minimizing injuries. While these advancements can certainly be appreciated, some of the antiquated methods of moving timber deserve a closer look.

Floating the Flume

Although flumes have been one of the more impressive ways to transport logs to a mill site, they were normally built when there was not a feasible alternative to transfer timber out of the woods. This was the case for the Skelley Lumber Company at the turn of the century. In 1906, they completed a 5.25-mile flume from Skelley Road into Drain. The flume followed Hayhurst Road along Bear Creek before angling into Drain. It terminated at a pond next to a planer mill along the railroad. Remnants of the mill still remain just off Aldous Lane.

The flume was a V-shaped trough that was filled with water from a source near the mill. These engineering marvels were actually relatively inexpensive and required low maintenance. "Flume herders" were tasked with keeping

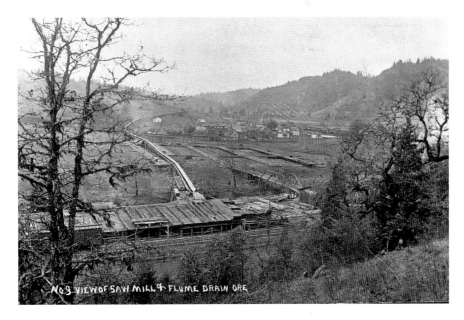

Skelley Lumber flume, Drain, Oregon. *Photo courtesy of the Douglas County Museum.*

SOUTHERN OREGON TIMBER

the flumes free of logjams and in good repair. The flumes were known for transporting timber quickly and efficiently; however, the main drawback to flumes was that they required a substantial amount of water to keep them functional. Author Larry Moulton tells, "In [July 1911], due to lack of water and other reasons, the company shut down…In 1924, the Skelley Lumber Company [mill and timber] property was sold."

BRUTE STRENGTH

Many of the loggers in the Pacific Northwest wore canvas waterproof pants called "tin pants" and heavy shirts known as "Mackinaws" for warmth. The "fallers'" tools consisted of axes, wedges, saws and sledgehammers. They would normally use an axe for an "undercut" in the tree, which would control where it fell. The loggers prided themselves on the accuracy of where the trees landed. In the Pacific Northwest, the sawyers usually worked in pairs.

The fallers stood on springboards placed in notches cut into the trees. The springboards usually provided better footholds than the soft and uneven ground below. They also elevated the men above the binding and saturated roots while at the same time giving them leverage for using axes and crosscut saws for cutting the tree down.

The saws were often up to fourteen feet long, as much of the early logging was done in old-growth forests. Sawyers would alternate pulling the saw across the tree. Turpentine or other oils were kept in bottles that hung nearby and were used to keep the saw from sticking. Wedges were strategically placed to keep the "kerf" wide open. Just as the tree was about to fall, a sawyer bellowed out *"TIMBER!"*

The "buckers" then cut the trees into transportable sizes and removed the limbs and branches (limbing). This was hard and dangerous work, as the large logs were susceptible to rolling over the buckers. When the trees were freed of bark, the true grunt work began. Oxen and large draft horses were used to drag the timber through the woods on wooden planks referred to as a skid road since the logs skidded along as they went. Buckers would often cut slightly rounded (sniped) ends on the logs, allowing them to slide more easily and with less resistance. The yoke of oxen were guided by a "bull whacker," who was said to have urged the cattle on by cursing and prodding when necessary.

According to the Collier Lumber Museum documents, "The 'punchers' spent their off hours nailing on oxen shoes (two plates to each cloven

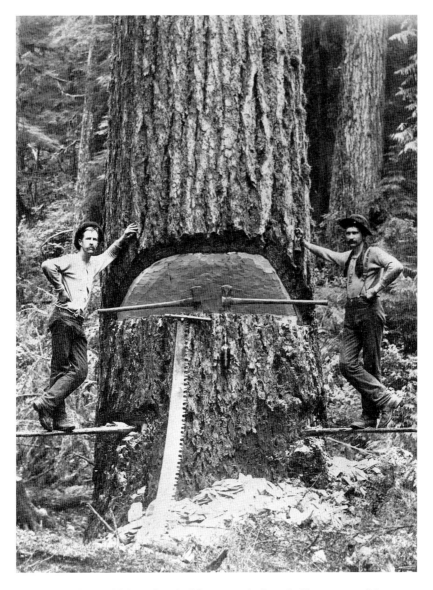

Frank Whittaker and Johnny Leach, fallers on springboards. *Photo courtesy of the Douglas County Museum.*

hoof), repairing the slings which went under the oxen's bellies and yokes which locked their heads together." A "skid greaser" spread grease or other liquid to lubricate the skids so the logs would slide more easily on their way down to a stream, wagon or train for transport to the mill. The

SOUTHERN OREGON TIMBER

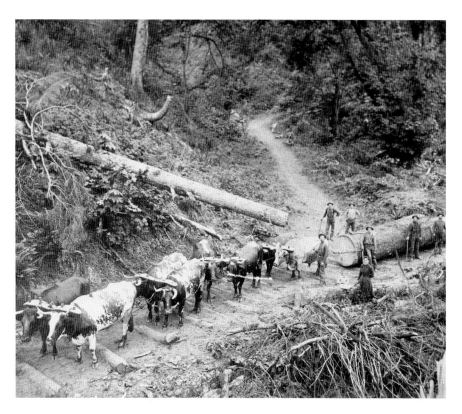

Oxen pulling a log on a skid road. *Photo courtesy of the Douglas County Museum.*

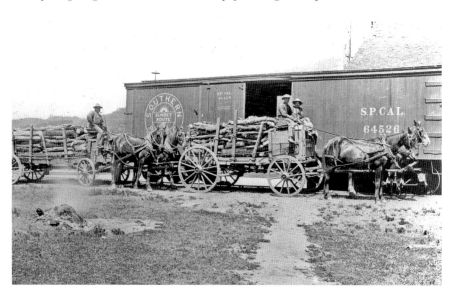

Loading wood into rail car, Riddle, Oregon. *Photo courtesy of the Douglas County Museum.*

animals were also used to help in loading logs. Subsequently, the animal labor was lessened with the advent of the wheeled skidder to help move the logs.

In 1881, John Dolbeer introduced the steam donkey. The donkey had a cable that was wrapped on a spool that pulled logs toward it, similar to a winch. A powerful steam engine on a small frame made it very adaptable in the woods for pulling or loading logs. They were also mounted on ships. In 1902, a lumber company in California used the donkey engine to power the stern-wheeler SS *Maru*. It was used to pull log "rafts" down the river to their mill.

Shortly after the steam donkey arrived, the steam-powered yarder was invented. It was larger than the donkey. It was used in the woods to pick up felled trees and for loading trees. The yarders were popular on railroad cars as well to aid in loading and unloading timber.

Down the Chute

On steep terrain, chutes were often implemented to move logs down the hillsides. In early years, a chute was used in West Fork, Oregon. It delivered the logs down to the railroad landing below. Chutes were engineered similarly to a flume, normally built with three logs arranged in a V shape to contain the cut timber. The main difference was that the chute didn't require water to operate, and it was normally shorter in length as well.

There were two types of chutes. The "running" chute worked entirely from the force of gravity as the logs were propelled down the steep terrain at lightning speeds. A "chute flagman" kept an eye on the logs and flagged the loaders when the chute was clear. At night, this was accomplished with the use of lanterns. The "trailing" chute was used on level sections along the ground. Logs were often helped along the way by horses or oxen.

These early techniques provided an interesting historical phase in the delivery of timber from the woods to the mills. These engineering feats, instituted before roads and other technology were readily available, certainly demonstrated the ingenuity of the early loggers.

SOUTHERN OREGON TIMBER

Logging Camps

These old camps seem like ghosts out of the past. But I still remember the men who used to work in them and the things we used to do. I guess someone coming along now would see the remains of our camps and wonder what sort of men worked there and who we were.

—*Gordon Fletcher, logger*

One essential component of most timber operations was a well-functioning logging camp. These Spartan and unadorned camps normally consisted of a cookhouse surrounded by bunkhouses as well as a company store and a blacksmith shop. Loggers who stayed in the camp paid a nominal fee for room and board that was deducted from their pay. Cooks were high-ranking workers in the camps since being well fed provided a boost in the men's morale. It was often said that the camps that provided the best food got the best workers. Loggers received three square meals per day, normally two at the cookhouse and lunch in the field. Salted pork and beef, beans, flapjacks and desserts were washed down with coffee and tea.

Wake up call was around 4:00 a.m. and breakfast was served at 5:00 a.m. By 6:00 a.m., the loggers were out in the woods. After a hard day of work, they arrived back in camp in the late afternoon. While many might equate the camp as a place to rest, loggers had plenty of work to keep them busy after dinner. Equipment was repaired and horses and oxen were taken care of while the crew sharpened axes and saws. They did find time to swap stories, and playing cards or reading under the dim lighting also helped pass the time. Lights out was usually observed around 9:00 p.m.

Sunday was their day off, and this was a time to tend to laundry and possibly visit other camps nearby. Often preachers and even salesmen passed through the camps on Sundays as well. Each camp usually had a man who gave the crew haircuts, just another way the loggers maintained their self-reliance in the remote woods.

The blacksmith shop was arguably the busiest and most important entity within the camp. Author Vernon Price suggested, "Without them [blacksmiths] there never would have been a lumber camp…They had to make horseshoes, heat all the iron on the forge and bore all holes in both steel and wood by hand." The blacksmiths also kept busy repairing just about every piece of equipment from sleighs to axe and hammer handles as well as cant hooks.

THE KENNETH FORD FAMILY LEGACY

When the living quarters started to feel cramped, a few loggers took it upon themselves to establish a separate residence away from the bunkhouse. Author Ralph Andrews told the story of the Mother Goose House: "A logger just couldn't get away from the trees. In 1901 he packed his living into a red cedar stump." This stump was modified to be complete with a window, roof and smokestack.

One camp utilized a large stump as a post office, while others made use of these enormous old stumps as storehouses. Still another story told of when there was an outbreak of lice in a Booth-Kelly Company camp near Wendling, Oregon. A bearded logger took matters into his own hands as he packed up his bindle and gear and lived in a hollowed out stump. His plan failed, however, as the lice invaded his new home, which was fondly remembered as the Wendling Stump.

2
OF MILLS AND MEN

From the onset of logging in southern Oregon, sawmills have gone through cyclical phases in their scopes and sizes. What started out as very rudimentary mills in the mid-1800s would become larger enterprises as regional mills came into existence in the latter part of the nineteenth century. In the mid-1920s through the Depression, the smaller mills made a comeback. This brought about a marked increase in what was known as "gyppo," or independent logging, operations.

The postwar boom in the economy brought a rise in prosperity. The demand for timber skyrocketed, and bigger, more efficient mills began to dominate the landscape. Increases in environmental regulations, vertical integration and the costs of implementing modern technologies and equipment in mills had weeded out the smaller "cottage industry" mills. The trend had reverted back to fewer but larger corporations remaining in the industry.

Sawmill Beginnings

The basic function of a sawmill is to convert logs into lumber. The first lumber produced in southern Oregon was cut by hand, often outdoors, in a process with a whipsaw with no resemblance to a sawmill's. Whipsawing was a two-man job. The sawing was in a vertical up-and-down motion with the log held up by a frame above a saw pit. Stephen Dow Beckham described

the equity of the sawyers' whipsaw operations: "These saws, operated by hand, required two men to work as a team. One stood on the top of a log; the other labored in the pit below the framing which held the log in position. The man on top was free of sawdust but had to pull up on the saw; the man in the pit had the advantage of drawing the saw down with the assistance of gravity, but he confronted a shower of sawdust and the danger that the framing might give way and drop the log on top of him."

Around the 1850s, the smaller, owner-operated mills converted from handsaws to circular saws. Hand power gave way to water power and eventually steam-powered equipment. Steam power led the way to gang saws and band saws, along with belt power used to drive conveyors. Some mills, however, were slow to change, mainly due to limited finances. Many of the early mills were portable, and when relocations or additions were made, it was with used or rebuilt equipment. Often at a separate location, planers were used to uniformly smooth the wood to the desired dimensions of width and thickness. Planer mills were common alongside railroad tracks, where the finished product could be conveniently loaded onto train cars for shipment.

As the mills became more permanent, boilers were added. Two boilers were often installed to keep the plant running in case one failed to operate. Scrap wood and slabs were used to fuel the boiler's fire tubes that created the steam for the plant. Inside dry kilns, the wood was stacked with enough space for proper air circulation to allow even drying as the steam-heated "dry air" flowed through and then out the exhaust system.

Southern Oregon still has a few remaining metal cone burners (wigwams) that give testament to past operations. Many have a rust-colored hue due to the extreme heat they were exposed to while burning the mill scraps and sawdust. Often they had a screened metal top to prevent ashes from escaping and starting fires. There were many other uses for sawdust, however. It was sold for packing around fruits, such as grapes, as well as insulation for ice. It also became a commodity for people who owned sawdust-burning stoves.

Early on, the noise and poor ventilation inside these mills created an occupational health risk for employees. Loss of hearing was common before earplugs were implemented. The noise was such that author Morgan Griffiths explained, "All communication between head sawyer and the setter, dogger and log monkeys was done by hand signals because of the tremendous noise levels and poor visibility due to sawdust in the air." The dust caused health risks with allergic respiratory and nasal complications for workers.

Fires were also commonplace in mills due to the extreme combustible nature of the sawdust and equipment that often caused sparks. Even early

lamps were fire hazards. Many mills attempted to create buildings allowing open air and adequate light. With technology, ventilation vastly improved within mills.

When the mills remained in a permanent location, millponds were added along with expanded yards for storing log cold decks. Water was applied to the decks to diminish the risks of spontaneous combustion during the hot summers. For the most part, until the mid-1860s, the local sawmills remained small in scale, but with the growth in the industry would come a change to larger, more efficient mills.

1860s: A Shift to Larger Mill Operations

As larger regional mills developed, several factors would play a key role in their location. First, there were limited modes of transporting the timber to the mill. The next important criterion was an adequate means to shipping lanes to export the finished products to the marketplace.

The Gardiner Mill Company

The Gardiner Mill Company had an ideal location near the confluence of both the Smith and Umpqua Rivers and the Pacific Ocean. The mill was established on a nine-acre plot of land in 1863 by four investors. With prime forests containing fir, cedar and spruce, the steep Coast Range Mountains of the lower Umpqua were ideal for logging. Timber was cut upstream along both rivers. Logging trees close to the water eliminated much of the labor-intensive removal and allowed for easy transport of the logs to Gardiner.

Early logging methods used on the Smith River were straightforward. The men used oxen to pull (skid) the logs along the wood-planked skid road to the river. They formed a raft of logs and floated them downstream to a sharp turn in the river above East Gardiner known as the "Devil's Elbow." Here, the logs were separated and cut to be processed in the mill.

On the steeper hillsides along the Umpqua River, dry chutes were used to slide the logs to the river. Splash dams were also instituted on creeks. Logs were used to dam the creek and to create a small pond. When enough logs had built up there, the workers pried open the log dam, causing a flash flood of logs to be swept down toward the river.

THE KENNETH FORD FAMILY LEGACY

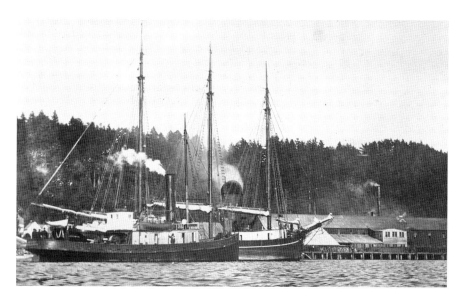

A lumber schooner and a tugboat, Gardiner, Oregon, 1915. *Photo courtesy of the Douglas County Museum.*

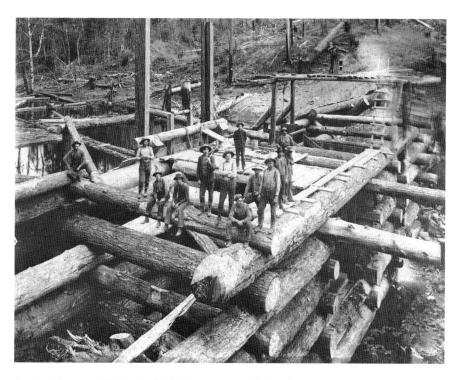

A splash dam on Mill Creek, 1905. *Photo courtesy of the Douglas County Museum.*

SOUTHERN OREGON TIMBER

The rivermen, many of whom couldn't swim, had a dangerous job transporting logs through splash dams and chutes and then downriver. In his book *Random Lengths*, H.J. Cox explained, "River loggers...considered themselves the peers of the woods loggers and referred to them as timber beasts, whose job of cutting down trees and dragging the logs out of the woods was inconsequential as compared to the ingenuity, perseverance and endurance in overcoming the moods and vicissitudes of Ol' Man River."

Depending on the water depth and flow, logjams were a common occurrence that had to be negotiated. In a narrow stretch of the river, horses were often used to tug at the logs to yank them free; otherwise a logger had to climb over the twisted pile of logs and break them free. The "peavey pole" was the basic tool of the riverman. It was normally a four-foot pole with a steel pointed spike used to poke logs and keep them moving and a hook to push and pull the logs. The "cant hook" was very similar to the peavey except it had a blunt tip.

Both the Umpqua and Smith Rivers were set with log booms (floating corrals to hold logs), which were situated at points along the way to the mill

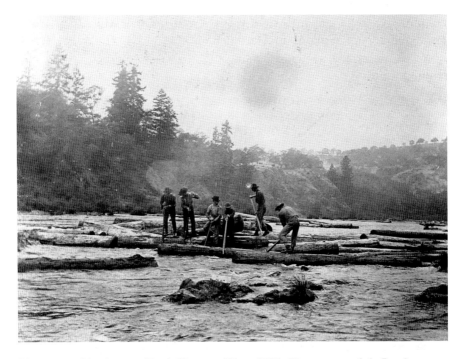

Rivermen rafting logs on North Umpqua River, 1910. *Photo courtesy of the Douglas County Museum.*

to aid in controlling the logs. Along the Umpqua River, tugboats were used to tow the log rafts to the mill.

The Gardiner mill would become an early success story in the trend toward larger mills in southern Oregon. Gardiner was, however, subject to several major fires. In July 1881, a fire started in the mill and burned it to the ground. It then swept through the town and destroyed thirty-nine homes and businesses. At that time, Wilson F. Jewett was a prominent figure in the mill. Jewett, like Asa Simpson, was originally from Maine. After the fire, Jewett offered free lumber to those who would help rebuild the city. In keeping with the traditions of the eastern seaboard, he campaigned for the residents to all paint their buildings white. Gardiner would then become known as the "White City by the Sea."

Jewett became mill superintendent in the mid-1880s, and eventually, he bought the mill and company store from Simpson and Hinsdale. The Gardiner mill operations were considered the most modern in the country, taking advantage of the latest technology. In 1904, the *Timberman* magazine called it a "splendid mill…[with] the latest logging engines."

After another fire burned down the mill in December 1916, Jewett built another mill, which he named the Jewett Lumber Mill. The second Jewett home still remains in Gardiner at 77175 U.S. Highway 101. It is listed under the Douglas County Historical Properties and is still painted white.

C.A. Smith and Albert Powers

As a teenager, Albert Powers was initiated into the world of logging as a water boy in Michigan. Early in his adulthood, he managed several large logging operations on the upper Mississippi River, near Hibbing, Minnesota. There he befriended C.A. Smith, with whom he would later form a business partnership in Oregon.

Upon moving to Oregon at the turn of the century, Smith purchased 27,532 acres from the Oregon and California Railroad. Later, in December 1906, Smith completed one of the largest land transactions in the Marshfield (Coos Bay), Oregon area. He purchased the lumber holding of E.B. Dean, including 30,000 acres of timber, logging railroads and a sawmill that employed 1,200 men. According to the local *Harbor* newspaper, "By virtue of the Dean purchase, Smith controlled more than 100,000 acres of timber in the Coos region."

SOUTHERN OREGON TIMBER

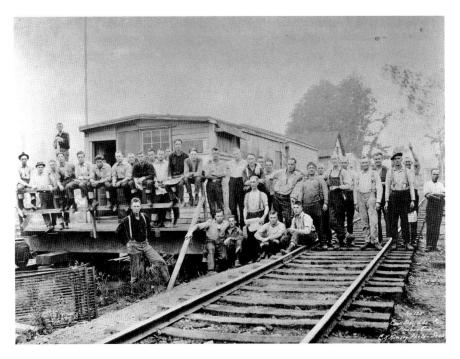

Smith-Powers camp with logging crew, Coos County, Oregon. *Photo courtesy of the Douglas County Museum.*

Al Powers moved his family out to Marshfield, and he and Smith formed a partnership in the Smith-Powers Logging Company. Powers began to develop logging camps along Coos River and other waterways that ran into the bay. At that time, more than four hundred men employed at their logging company had worked for Powers in Minnesota. He used a motorboat to oversee the widespread logging camps. The *American Lumberman* described him as "the personification of energy."

As business continued to flourish, the company built a railroad in 1912 from Myrtle Point along the South Fork of the Coquille River in order to reach their remote timberlands. This led to the establishment of more logging camps in the area and the purchase of the 166-acre Wagner Ranch. Powers had the ranch surveyed and platted in order to build a logging town there.

Because he enjoyed sports, he built a baseball park there and set aside an area for a school. The company also built a power plant, an office and a machine shop as well as a company store. The employees could buy lots for homes in town for $300–$700.

THE KENNETH FORD FAMILY LEGACY

A roundhouse was built with the completion of over twenty-one miles of rail and several railroad spurs into the heavily timbered areas that supported about eight camps. After the completion of the track on May 2, 1915, passenger trains carried in about five hundred people to celebrate the new town. The area had been known as Rural or Wagner for years, but eventually the loggers voted to change the town name to Powers.

Weyerhaeuser

In 1852, at age eighteen, Frederick Weyerhaeuser emigrated from Germany to the United States. He went to work in a sawmill in Rock Island, Illinois. Several years later, when that business failed, he bought it. As a true entrepreneur, he began to buy timberland and controlling interests in milling operations throughout Wisconsin and Minnesota. He and his brother-in-law Frederick Denkmann went into business together.

Weyerhaeuser moved to St. Paul, Minnesota, in 1891. By chance, he befriended his neighbor James J. Hill, a railroad mogul. After Hill completed the "Empire Builder" route for his Great Northern Railway from Minnesota to Seattle, he bought 160 acres of land in Montana from the local Blackfeet Indians. To encourage passenger service, James and his son Lewis began building hotels and chalets in Montana's newly established Glacier National Park.

In 1900, Frederick Weyerhaeuser and fifteen other investors bought 900,000 acres of timberland in Washington State from James Hill. They paid $6 per acre, making it the largest private land transaction in American history at that time, with a purchase price of $5.4 million. Considering the prices he received for the timber, it was later determined that Weyerhaeuser had paid only ten cents per thousand board feet (a board foot equals two by six by twelve inches).

This extraordinary purchase would change the dynamics of the timber industry in the Pacific Northwest. Author Stewart Holbrook referred to this new type of corporate venture as a second migration. This one was of timber barons and their cruisers. "The barons took one brief look at the huge timber stand...and bought timberland great, large, wide long hunks of it." He explained, "It isn't a matter of timber. There is plenty of timber...But timber is being harvested, mostly, by a new and different breed of men—men who smoke many cigarettes but chew little plug; men with families, who wear conventional clothing, vote in elections,

and play tennis and golf. Few of them need to know how to handle ax or peavey."

By 1913, the Weyerhaeuser Timber Company would become the largest in the nation. These large interstate purchases of timberlands by the company had set a new standard throughout the industry. This paved the way for other timber barons and corporations to do the same. This paradigm change had a big impact on the industry, making it harder for the smaller loggers to compete for timber acreage. Without a reliable supply of timber, many small mills were forced to sell out to the larger conglomerates.

Vertical Integration

In vertical integration, a company seeks to maximize its "economies of scale" by purchasing and owning its entire supply chain. This practice eliminates the middlemen and keeps production costs lower. For example, Andrew Carnegie owned the mines and raw materials used to make his steel, and in addition to the factory, he also owned rails and shipping vessels to deliver the finished products.

Several timber enterprises practiced partial integration. Asa Simpson built a fleet of ships to deliver his lumber products, as was the case with Robert Dollar. Still other companies experienced vertical integration by default. The isolation of their mill towns often necessitated that they offer housing and a company store. As a businessman, Robert Long, of Kansas City, was influenced by Andrew Carnegie and went on to purposely practice vertical integration.

By 1900, Kansas City had risen to become a prominent lumber center. It was ideally located at the junction of the Mississippi and Kansas Rivers. With a prime location in the center of the United States, it also became the hub of thousands of miles of railroad tracks. Raw materials and timber were brought into the city for manufacturing while over four thousand rail cars of finished lumber were being shipped in all directions.

At this time, the Long-Bell Lumber Company had a large presence there. It built the city's first "skyscraper": the R.A. Long Building, which, at sixteen stories high, towered over the area. The company had been established in 1877 by Robert Long and Victor Bell.

By 1906, the Long-Bell Lumber Company owned 250,000 acres in the southern states of Arkansas, Louisiana, Texas and Oklahoma. The company controlled everything from the timberlands and sawmills to the retail yards.

Wholesale distribution of Long's lumber was aided by his venture into railroads, living up to his company's maxim: "From Tree to Trade."

Robert Long was a strong proponent of owning an entire company town. His first foray into this concept was around 1901. In California, Abner Weed established the Weed Lumber Company and soon purchased 280 acres in the area along with the Siskiyou and Mercantile mills. He aptly named the town Weed. With these mills, he formed a corporation with Robert Long. In 1905, Long bought Weed out, so the mills and much of the town became part of the Long-Bell Lumber Company. Long was indeed running a company town, with most employees living in homes on company land. Shopping at the company store was expected of employees. Long-Bell also operated an extensive network of railroads in the area.

But Long had even bigger aspirations in Washington State. He purchased 14 acres along the Columbia River for a company mill site and town. Eventually, he would purchase 270,000 acres of Douglas fir in the state. Along the river, he built two state-of-the-art, all-electric mills that employed three thousand workers. One of the mills laid claim to being the largest lumber mill in the world at that time.

The town was surveyed and platted and would be named Longview, Washington. The initial idea for the town was for employees and other commercial interests to support the mills. However, Long spared no expense as he brought in J.C. Nichols, recognized for designing the "Plaza" district in Kansas City, along with an architect and city planner.

On February 14, 1924, the town was incorporated as a city with a population of nearly eleven thousand. It had as its centerpiece the two-hundred-room Hotel Monticello along with numerous retail shops and company buildings. Longview is currently the largest city in Cowlitz County.

Robert A. Long was a successful timber baron who used vertical integration to build what was the Long-Bell Lumber Company Empire. He died in 1934, and the company declared bankruptcy the following year. However, it restructured its debt and reemerged. The International Paper Company purchased the holdings of the Long-Bell Lumber Company in 1956.

SCALING BACK

As larger mills continued to practice vertical integration, they began to look at greater expansion into foreign markets as well. World War I had

stimulated the timber industry with the production of war materials for airplanes, ships and other military equipment. However, the postwar timber economy was in a slump. According to the Department of Congressional Records, there was a 34 percent decrease in lumber and timber production. The Forest Service found that the decrease in the amount of timber cut in Oregon was due to less demand for products, which in turn led to lower prices. There was still a need for improvements to the infrastructure of the logging operations. More roads were constructed to reach the outlying timber stands and to deliver the lumber to the marketplace.

The 1920s also began a new era in the Pacific Northwest's timber industry as more independent loggers and mill owners went to work in the forest. With smaller-scale operations, they were able to access some of the hard-to-reach corridors of timber. Because they ran on a shoestring budget, they needed to turn out large volumes of timber as efficiently as possible. The gyppos were originally known in a derogatory sense, as people worried they would be "gypped" of their wages by these independent outfits that operated with minimal capital.

Gyppos seldom owned the timberland and often cut timber with a small portable mill and flatbed truck. They sometimes worked without a contract—nothing to secure payment for their labor. Author William Robbins explained the gyppo logger was "a hardy individual who worked on marginal capital, usually through subcontracts with a major company or broker, and whose equipment was invariably pieced together with baling wire."

With this increase of smaller logging operations, the Forest Service was put to task in monitoring their operations and stewardship within the forest. Bill Hagenstein, who would have a big influence on the reforestation projects in Oregon through tree farms, explained the methods used in early logging: "In those days, loggers cut all the trees they wanted in one area, then moved to another piece of land and started over. They didn't plant new trees; they left the forest to grow back itself."

Oregon had become known as the last frontier for timber. The timber companies were advancing their presence from the Willamette Valley to the woods of southern Oregon.

The progression of the Roaring Twenties eventually brought back an increase in lumber production. However, when production hit its peak in 1929, the economy began to stall, resulting in surpluses of lumber and timber-related products. The prices were dropping right in line with the

THE KENNETH FORD FAMILY LEGACY

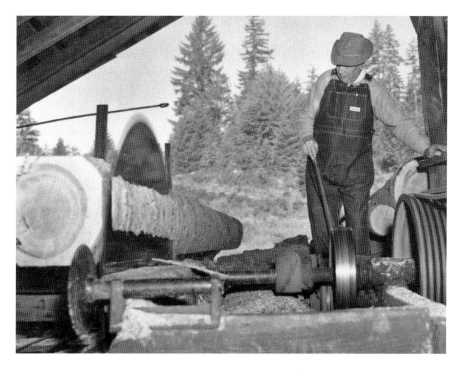

A gyppo logger at Rock Creek. *Photo courtesy of the Douglas County Museum.*

beginning of the Great Depression. Because of these surpluses, the timber industry was hit especially hard.

Many workers were laid off as larger conglomerates struggled to defer the costs of inventory and the high costs of maintaining their facilities. The Pacific Logging Congress reported an interesting trend in the Douglas fir region between 1928 and 1939. "In a period when many large operators went out of business and production slumped, the number of individual logging operations practically doubled."

MODERN ERA

After World War II, the trend began to revert to larger, more efficient mills. With smaller operating margins, companies continued the modernization and automating of their mills. They also began to farm out many of the logging operations in order to decrease their labor-related costs.

SOUTHERN OREGON TIMBER

Timber companies slowly phased out the use of their own trucks and logging equipment. Today, they contract work with a different standard of independent operators, who play an important role in the industry. These operators concentrate on one aspect of the business and use top-of-the-line equipment with highly trained professionals to perform the logging jobs in the woods.

Another trend in the industry has been lumber companies that sell off their mills and focus only on managing their timberlands. This "corporate timber management" has become big business, with timber being sold to mills through timber brokers. Private timber is being bought up by developers, who separate the valuable real estate and timber stands. Traditional lumber companies are becoming known more for producing a wide variety of forest products.

3
A BALANCING ACT

Throughout the history of logging, there has been a longstanding debate over the proper management of our forests. To help assess the conditions in the forests, Congress established the Office of Forestry within the Department of Agriculture. This was soon expanded to form a larger bureau, the Division of Forestry, in 1881.

The standard practices by the loggers early on led many to question their ethics. Logging beside rivers and streams was not only convenient but also cost and labor effective. The economies of scale played a large part in selective cutting and harvesting of old-growth trees as well. In defense of the loggers, there was no empirical information at that time that stated these practices could be harmful to the environment.

THE LEGISLATIVE CONSERVATION YO-YO

The Forest Reserve Act of 1891 allowed the president of the United States to set aside forest reserves, claiming them under public domain. What transpired on the Olympic Peninsula in the coming years exemplified the differing viewpoints throughout the country on the conservation of timber resources. Author Howard Brier explained: "In 1897…President Grover Cleveland, employing a power granted him by the Forest Reserve Act…set aside 2,168,320 acres on the Olympic Peninsula as a forest reserve.

In 1901 President William McKinley, yielding to pressure from settlers and lumber interests, reduced the size of the reserve by 750,000 acres. President Theodore Roosevelt restored 127,000 acres in 1907."

Meanwhile, in Oregon, President Harrison created Oregon's first reserve, the Bull Run Reserve, in 1892. It contained 142,000 acres. The next year, President Cleveland designated reserves of over 4.5 million acres. By 1907, Roosevelt had enlarged the Cascade Range Forest Reserve to temper relations between conservationists and the timber industry.

In 1905, the U.S. Forest Service was established by Gifford Pinchot. Its main objective was the ongoing protection, maintenance and restoration of forestlands. However, its legitimacy would soon come under question. In 1909, Roosevelt authorized a 650,000-acre national monument centered in the Olympic National Forest. By executive order in 1915, President Woodrow Wilson cut the size of the monument by half. At this early date in history, the battle lines were being drawn as conservationists accused the Forest Service of "being in league with the big timber interests."

Before the beginning of World War I, the dust had begun to settle from the contentious early years of expansion and contraction of timber reserves under the Forest Reserve Act. It had appeared to Henry Graves (who then headed up the Forest Service) that a balance had been reached through their efforts in managing the forest. He wrote, "When the policy of deeding away the public timberlands was at last found an unsafe one for the Nation, it changed and the bulk of the remaining public timberlands were withdrawn from public appropriation and segregated as national forests…The public forests are being protected from fire, the timber is used as it is called for by economic conditions, and the cutting is conducted by such methods as leave the land in favorable condition for the next crop of timber."

FORESTRY AS A SCIENCE

The creation of the Division of Forestry gave testament to the growing science of forestry, and many universities began adding forestry to their natural resources curricula alongside botany and ecology. In 1900, Yale alumni Gifford Pinchot and Harry Graves began the Yale University School of Forestry. Both men had received professional training in forestry in Europe. Graves would become dean of the program until 1910, when he took over the U.S. Forest Service post vacated by Pinchot.

THE KENNETH FORD FAMILY LEGACY

The University of Montana supported this expanding discipline with a school to train Forest Service rangers in 1908. The Oregon State Agricultural College established a professional forestry program in 1910. After securing its forestry program, the University of Washington received large federal grants of land. Although some of it was sold, the university retained 70,000 acres for experimental practices. It also set aside a 270-acre arboretum "laboratory" for forestry students, near its campus in Seattle.

Selective Logging

The growing use of "selective logging" by western loggers brought about a clash with the Forestry Service regarding the definition of this terminology. Foresters had long used the term with a different connotation. To them, selective logging was a term used for the practice of selecting trees to be cut on the basis of what is good for the forest. Their policy sought to maintain

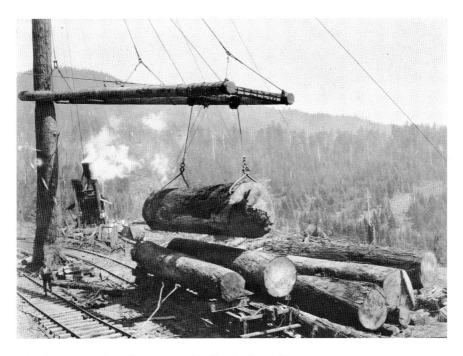

A log boom operation. *Photo courtesy of the Douglas County Museum.*

a healthy diversity of tree species within the forest while avoiding the elimination of a particular species from an area.

Foresters contended that selective logging in the timber industry was merely economical and that tree selection was only a means of generating a profit. This, they believed, led to "high-grading," which removed the larger, healthier tree species while leaving behind slash and poorer-quality trees.

The world wars expanded a different variation of selective logging called "market-driven logging." The wars disrupted the balance by creating an immediate need for military equipment such as airplanes, ships and lumber to build military barracks. This created an increased demand for specific species of trees.

In World War I, airplane manufacturing accounted for the use of 143,008,961 board feet of spruce in one year. It was extracted primarily from forests in Washington and Oregon. There was an increased use of market-driven fir for shipbuilding. In 1942, during World War II, the military was responsible for the purchase of 18.0 billion board feet of timber, while the civilian population accounted for only 17.6 billion board feet.

Who Stole My Trees?

Clear-cutting practices continued in the industry as the demand for lumber increased. There was not much regulation, especially on private lands. However, the Oregon Conservation Act of 1941 called for more control of private timber cutting, and this had the approval of the private industry. By default of unpaid taxes, thousands of acres of private timber were transferred back to state and local governments.

So after World War II, there was an era when more timber was available from government land sales. This land was often sold at discounted rates. Mills at this time were less concerned with efficiency, as large amounts of sawdust and slabs went up as smoke in wigwam burners. But a new consciousness was growing in America, putting an end to the smokestacks and outside burning. Companies began to reduce waste through technological improvements of equipment as well as the expansion of wood products.

The government became more involved in how the forests would be maintained. In 1946, President Truman combined the General Land Office and Grazing Service to form the Bureau of Land Management (BLM), which controlled nearly 250 million acres. In that same year, Secretary

THE KENNETH FORD FAMILY LEGACY

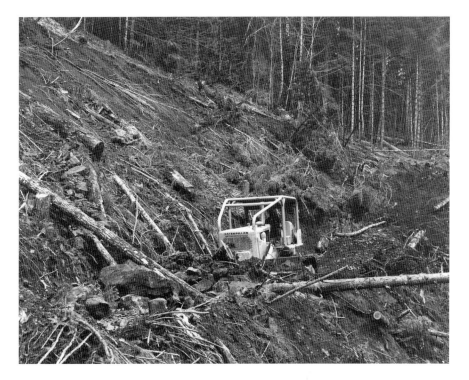

Building a road for timber harvest. *Photo courtesy of Allyn Ford.*

of the Interior Harold Ickes rose to the forefront of the timber debate in his criticisms of timber industry practices. He was quoted in an article of *Liberty* magazine titled "Our Vanishing Forest." Pictured in front of an area that had recently been clear-cut, he proclaimed the rally cry for future environmentalists: "Until the lumberjacks stripped this hillside, it was a forest. Now it's prey for erosion."

What he failed to mention was that timber is a renewable resource, and in years to come, that area would again be a viable forest. The *Timber Resource Review* responded with a rebuttal pointing out how much timber was being destroyed by natural causes such as insects like the bark beetle, diseases and especially fires. It stated that by 1955, tree farms in the industry would grow more trees than were lost by natural causes and harvesting.

A variety of bark beetles preyed on the fir and pine trees of the Pacific Northwest. They lived under the bark, making them difficult, if not impossible, to control. Old-growth timber was often more susceptible to beetle infestation. One school of thought that was implemented to save the timber was to log it before the beetles destroyed the wood. However,

this technique usually involved building more roads deeper into the remote reaches of the forests, which led to more contention.

Tree farms were first advocated by M.L. Alexander of the Louisiana Department of Conservation when he proposed "tree farming on cutover land." Interestingly, in 1935, forest conservationist Gifford Pinchot wrote, "Wood is a crop. Forestry is tree farming." This concept caught on, and in June 1941, the country's first official tree farm was dedicated in Washington State. The Clemons Tree Farm was a 120,000-acre plot owned by the Weyerhaeuser Timber Company.

This led to the development of the West Coast Tree Farm Program for the Douglas fir region of Washington and Oregon, and by 1942, there were sixteen more tree farms in the United States covering over 700,000 acres. By 1980, there were over thirty-nine thousand tree farms covering over 79 million acres.

Fire Prevention Methods

Fires have indeed wreaked havoc on the forests of the Pacific Northwest. In 1902, fires destroyed over 700,000 acres of timber in Washington and Oregon. In August 1933, the Gales Creek Canyon fire near Tillamook, Oregon, burned over 300,000 acres with an estimated 12.5 billion board feet of marketable timber lost in a matter of weeks.

By 1940, studies into the causes of forest fires determined that nine out of ten were caused by humans. Therefore, several campaigns began in order to inform and educate the general public on how to prevent starting these fires. Washington State began a program called "Keep Washington Green." The state hired renowned timber author Stewart Holbrook to serve as its director. Other states initiated similar movements. Soon to follow was the national Smokey Bear fire prevention campaign. Its first slogan was "Smokey says—Care Will Prevent 9 out of 10 Forest Fires." Its motto, "Remember, Only You Can Prevent Forest Fires," is still recognized today.

By the mid-1950s, these efforts had proven successful, as the number of fires had decreased significantly. The Forest Service and the timber industry had worked closely together, which helped to preserve both wildlife and its habitat from fires. The addition of forest service roads and improved equipment had also made an impact.

The balancing act between proponents of the timber industry versus the conservationists and environmentalists will always be a hot topic. As in the

past, it remains at the political forefront in America. The study of forestry as an academic discipline has benefited both the Forest Service and the industry practices.

However, the scientific data would also present further lines of division in the implementation of policies and procedures as to what was necessary to maintain healthy forests in the future. Although the pendulum has often swung wildly with mitigation aimed to appease both camps, some positive progression has been made on many important issues as a result of the continued dialogue. As the availability of timber for harvesting has dwindled, the timber industry has continued to make strides in production efficiencies.

4
WILLAMETTE VALLEY

Upon arriving in Oregon, lumbermen had several qualifying factors in the selection of timberlands for logging. With fluctuations in the marketplace, many Oregon loggers remained somewhat nomadic in keeping up with supply and demand. The changes in wood products required the usage and therefore demand of differing tree species. This further evolved into a necessity to accommodate higher grades of lumber quality as well. Southern Oregon communities experienced the ebb and flow of the industry as sawmills came and went. There was a tendency for loggers to cut and go, moving on to the next lucrative timber stand.

America's entry into World War I in April 1917 would cause further disruptions within the industry. Forester Henry Graves was commissioned as a major in the Army Corps of Engineers. The military also recruited experienced loggers and foresters. Some were sent to France to assist in the cutting and manufacturing of their timber for the war effort.

The soldiers who stayed in the United States became part of the Spruce Division (SPD), which was a unit within the aviation department in the U.S. Army Signal Corps. The division was created in a cooperative agreement with war allies Britain, Italy and France. It was created primarily to ensure that high-quality spruce wood would be used in combat airplanes. This would make a lasting impact on the Pacific Northwest timber industry. Prior to turning out these large quantities of spruce for the war effort, there had been little demand for spruce in the western states.

Spruce was used largely in the wing spars and fuselage framing. It also was a laminate for the airplanes' wooden propellers. Sitka Spruce was highly sought after for its strength and light weight. It also would not splinter when struck by bullets. The military's operation center was located at Vancouver Barracks, Washington, where they opened a sawmill in early 1918.

In all, there were over twenty-five thousand soldiers who were stationed in various lumber mills and about sixty logging camps throughout western Washington and Oregon. The soldiers worked directly with experienced civilian mill and logging employees while living under military protocol. This required the army to establish a special union to support the soldiers working in the mill. It was known as the Loyal Legion of Loggers. By the time things were ironed out, the actual Spruce Division was in full production for only about fifteen months.

Ultimately, on June 28, 1919, the Treaty of Versailles formally brought an end to World War I. Americans sought a sense of normalcy, distancing themselves from the war and other world affairs. The country began to look inward, setting its sights on a domestic agenda. While the wartime production had stimulated the economy and especially the need for timber-related products, the abrupt ending of the war left large surpluses of timber. The government soon instituted a program to aid displaced loggers in finding jobs.

Establishing Roots

Prior to the war, the development of railroads had opened up shipping lines across the country. The Southern Pacific (SP) Railroad Company began to partner with mills to add additional rail spurs for easier loading and transporting of lumber cars. SP also offered more competitive rates by reducing lumber rates by 10 percent for loads originating in Oregon and shipped to other SP locations nationwide. In some heavy-use areas, the rail company maintained specialized freight routes catering to the needs of the local timber industry.

The Willamette Valley had experienced an influx of growth, and the area was teeming with mills. The region quickly developed into one of the hot beds for timber in Oregon. The Mill City branch of SP was established within the valley. There were sixteen stations located on this thirty-five-mile

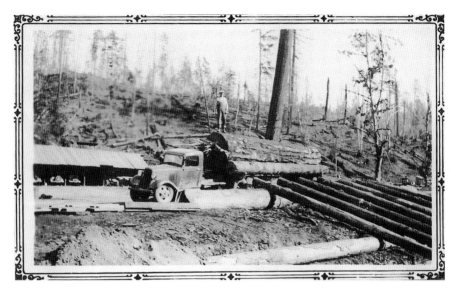

Unloading logs. *Photo courtesy of Allyn Ford.*

section of rail. Many of these stations were actually siding mills, where empty rail cars were dropped off for loading on scheduled days and loaded cars were picked up on alternate days.

THE LEONA MILLS LUMBER COMPANY

Located along the SP Railroad on the southwestern tip of the Willamette Valley was the town of Leona. In the 1880s, a sash mill was operated in the area by Newton Mulvaney. At that time, the post office named the town site Hudson; however, it was later renamed after Mulvaney's granddaughter Leona. At the turn of the century, under new owner J.J. Kenny, the company expanded with the purchase of over 1,700 acres. It upgraded boilers and equipment, which by 1917 included seven steam donkeys in the woods and nine logging trucks. They manufactured lumber products, which were sold through dealers as well as a branch office in Roseburg.

The company, which operated under a few different owners, overcame several fires and closures over the years until it succumbed to financial difficulties in 1928. It was reorganized in 1929 as the Roy A. Beebe Lumber Company, but on May 25, 1930, the mill was completely destroyed by fire.

THE KENNETH FORD FAMILY LEGACY

According to the *Timber Times*, "In 1933…the equipment was sold off, mostly for scrap, and the camp closed down for the last time…The 1920's vintage Smith & Watson two-speed yarder was said to have been purchased from the Leona Mills operation by the Chapman brothers, southwest of Drain, Oregon, who eventually gave it to the Douglas County Museum, in Roseburg, where it resides today."

THE BOOTH-KELLY LUMBER COMPANY

Robert Booth, along with partners George and Tom Kelly, formed the Booth-Kelly Lumber Company in 1896. The company was a permanent fixture in Springfield, Oregon, where the partners purchased a sawmill in 1901, along the Mill Race waterway. They maintained a presence there until 1958, when the mill was sold to Georgia Pacific.

Perhaps the most ambitious timber operation in the Willamette Valley was carried out by Booth-Kelly Lumber when it bought a mill in the adjoining Mohawk Valley in 1898. The mill, originally known as Holcomb's Mill, was located at the confluence of Wolf and Mill Creeks. It changed hands a couple times before it was sold to Booth-Kelly, which bought the mill with the intent of creating a mill town on the site. The town was officially named after one of the sellers, George Wendling. It sprang up quickly, with over fifty bunkhouses and cottages built for single loggers as well as for those married

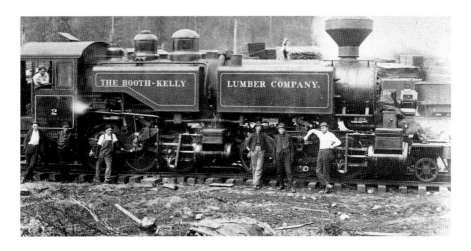

Booth-Kelly Lumber Company, Engine No. 2. *Photo courtesy of the Douglas County Museum.*

SOUTHERN OREGON TIMBER

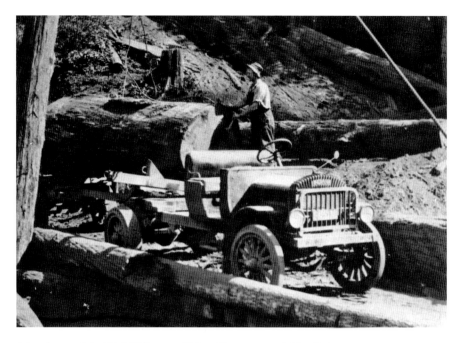

A logging truck in 1926 Willamette Valley. *Photo courtesy of Allyn Ford.*

with families. Electricity powered the company mill and store, which were quickly surrounded by a spreading metropolis, including a post office, school, church and resident physician's office.

By the turn of the century, the Willamette Valley was teeming with activity from numerous lumber mills. A stagecoach line began operating out of Springfield, stopping in Wendling and throughout the valley several times a week. This growth caught the eye of the SP Railroad Company, and it extended the Springfield-Wendling railroad branch. It offered both freight trains and a passenger service on the "Wendling Bullet." In addition to the SP rail, Booth-Kelly laid twenty-six miles of its own tracks. The company purchased locomotives and reportedly had more than a dozen flat rail cars.

At the height of the town's operations, it had grown to upward of one thousand people. Built close to the timber, the town was susceptible to fires. In 1910, a fire torched much of the town site, but the mill was left intact. Twelve years later, another fire destroyed much of the mill, and then, in 1946, a fire would decimate the Wendling mill. With the timber supply in the area dwindling, the once bustling mill town had been all but abandoned, and in 1959, the woodlands were sold to Georgia Pacific. Today, there are few remnants of what was once Wendling, Oregon.

5
SAWDUST IN THE VEINS

THE CLAIR FORD FAMILY

Clair Ford was born in Bridgeman, Minnesota. In 1891, when he was six, his family moved west, settling near Walla Walla, Washington. He married Ora Randolph in Moscow, Idaho, in June 1906. Ora was born in Galt, California. At the age of five, she moved with her family by wagon to Moscow, Idaho. Prior to getting married, Ora attended the University of Idaho. She then taught school and operated a dressmaking shop in Grangeville, Idaho.

During their first years of marriage, Clair was employed at various sawmills in the region. Clair and Ora had three children: Kenneth, who was born in Asotin, Washington (August 4, 1908); and two girls, who were born near Enterprise, Oregon—Edith (May 10, 1910) and Lois (May 28, 1911).

Eventually, Clair gave up on the nomadic life of sawmilling, moving the family to the Richland-Sunnyside, Washington area to settle down and try his hand at farming. But his daughter Lois told that, unfortunately, "the farm financially didn't work out. Dad had been in lumber before, and it was his love, so it was natural for him to return to it."

The Willamette Valley offered opportunities for Clair to return to logging. He originally moved to Blodgett, Oregon, in the early 1920s and then to the Lacomb area, where he became superintendent of three

small mills for the Dimension Lumber Company. Carmen Ford explained that when Clair left to work in Lacomb, Ora and the children stayed in Sunnyside to run the farm. "Grandma Ford was a very independent, strong and stubborn woman."

A Lifelong Education

Later, in 1926, Kenneth moved down to Oregon to work in the mills while attending his senior year at Lebanon High School. He lettered in basketball and was among the forty-three students to graduate that year. With Kenneth's eagerness to earn money, Clair found plenty of jobs for him around the mill. Kenneth also hauled lumber to a planer mill and Southern Pacific Railroad siding about six miles west of Lacomb in Brewster.

After graduation, Kenneth had saved his money and went to college to study engineering at Oregon State Agricultural College, known today as Oregon State University. However, before college, he had made a $1,500 loan (a large sum of money at the time) to his uncle Cecil, who ran a mill and siding just outside Salem. According to Kenneth's sister Lois, "He

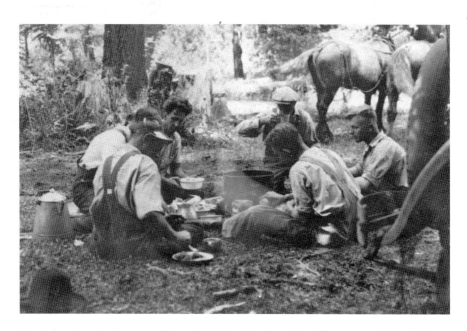

Lunch break at a logging camp. Kenneth Ford is sitting front right. *Photo courtesy of Allyn Ford.*

THE KENNETH FORD FAMILY LEGACY

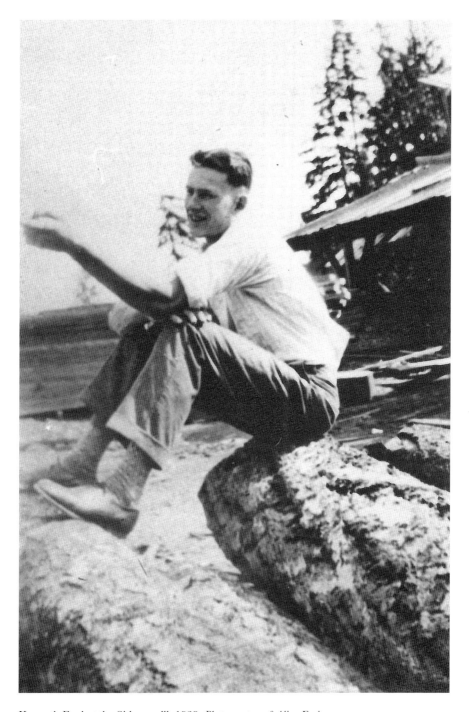

Kenneth Ford at the Sidney mill, 1928. *Photo courtesy of Allyn Ford.*

SOUTHERN OREGON TIMBER

[Cecil] borrowed $1,500 from Kenneth but couldn't run the mill properly. So Kenneth either had to lose the money or go down and take the mill over for himself and run it. And that is what he did." So in 1927, he left college after completing only one term and began managing his first sawmill in Sidney, Oregon. The decision to leave school would have a lasting impact on Kenneth.

A Career in the Mills

The primary sawmill supervised by Clair Ford was about two miles southeast of Lacomb on what was known as the Klaymer Place. According to resident Harvey Kleinschmit, Beaver Creek was dammed to create a millpond. It was fortified along the creek side with timber planks. Adjacent to the mill sat a wigwam burner. As a school-aged boy, fellow resident Waldo Smith remembers watching the activity around the mill with other kids. He remembers "about ten" small tarpaper houses for employees. Smith explains, "There were

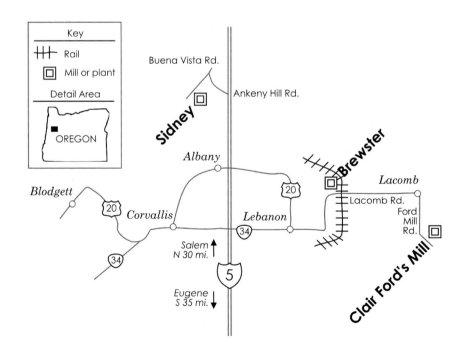

Map of Lacomb area, Clair Ford's mills. *Created by Amy Goodwin.*

trestle [plank] roads that were used to get to the county roads due to muddy conditions. One was about three hundred feet in length. There was also a railroad siding and planer mill located six miles west of Lacomb in Brewster. This mill consisted of a planer, green chain shed and loading dock. It sat directly across from the 693 railroad mile marker."

During this time, the timber supply in the Willamette Valley was getting harder to maintain, as the competition was increasing. Timber outfits like Santiam Timber Corporation, Willamette Valley Lumber Company and Hammond were increasing their presence around Lebanon.

A New Opportunity Beckons

Clair had heard that Roseburg had plenty of timber, and he began searching for a mill site there. On September 26, 1927, the *News Review* reported that C.H. Ford of the Lacomb-Lebanon area was prepared to install a sawmill in North Roseburg. Elmer Giles, a prominent timber broker in Roseburg, was working to help Clair find a suitable mill site as well as timberland.

It is probable that Giles and Ford may have become acquainted after Giles and a realtor from Lebanon closed on a large property deal in Portland in October 1926. The $180,000 realty deal involved cash and 640 acres of timber in Douglas County. Giles would serve as both a liaison and a spokesperson on Clair's behalf as he continued to work on relocating to Roseburg. He would prove himself to be a valuable ally in obtaining both standing timber as well as a desirable mill site with access to the railroad.

There was a promising report from the *News Review* on May 18, 1929:

Sawmill to Be Erected in Roseburg

Negotiations that have been pending for several weeks for the construction of a sawmill in Roseburg have been completed and the mill will be set up and ready for operation within the next 60 or 90 days, according to [an] announcement made today by E.L. Giles, local timber broker, who has been conducting the deal. The mill is a practically new outfit that is being moved from Lebanon, where the tributary timber has been cut away, and will be located in north Roseburg just west of Sixth Street on the extension of the Creason Spur. The mill will be operated by C.H. Ford and son, of Crabtree, Oregon, experienced mill men who have taken options

on seventy-five million feet of timber east of Roseburg in the Lane Mountain and Whitsitt Butte districts. Mr. Ford, who will install and operate the new mill, has had a great deal of experience in that line of activity. He served as an employee in a number of large mills and has also operated several plants of his own. In recent years he has been connected in an official capacity with the Dimension Lumber Company of [Ridgefield,] *Washington, and has been representing that concern in Washington and Oregon. He has tendered his resignation to the Washington firm and will leave their employ on July 1, at which time he will move directly to Roseburg to reside. He will be accompanied by his son, who is now engaged in mill work at Lebanon…It is planned to put in a complete electric plant…*[and] *install a planing mill at a later date…The mill is to be placed on a four block tract near the intersection of East Street and Second Avenue South. The Creason Spur is to be extended to the mill giving a railroad connection. The property has been leased to the company by Mr. Creason at an exceedingly low figure, because of his desire to see a payroll industry established in Roseburg. Mr. Creason gave a long term lease on the land at such a price that it practically constitutes a gift during the time that the mill is in operation. The mill will have a daily capacity of 30,000 board feet, and will furnish employment for 50 to 60 men in the mill and in the woods. The work of moving the mill according to Mr. Giles is to be started within the next month.*

Interestingly, the mill in Roseburg was originally planned to be named Clair Ford and Son. As the Roaring Twenties were coming to a close, the expectations for the mill were running high. The Fords assured a $100,000 annual payroll. Plans were continuing to progress, as Kenneth's sister Edith Hull explains, "In the summer of 1929, the company's one and only Cat was hauled to Roseburg on the old hard-tired Mack truck. Two men came with the truck and lived in a house up on the hill behind Benson School. These men dug the pond and moved the equipment back to Lebanon." With the excavating finished and the Creason Spur extended, things were indeed taking shape as the summer came to a close. In late September, E.L. Giles said that the building of a roadway into the timber on Lane Mountain would be completed before "the wet season."

THE KENNETH FORD FAMILY LEGACY

A Change of Fortune

Giles would later need to retract his prediction. He explained that erecting the mill in Roseburg would be "considerably delayed, due to the fact that one of Mr. Ford's mills in the Willamette Valley was destroyed by fire, so that it became necessary for him to move the Lebanon plant that he had proposed to bring to this city, to the site of the burned mill."

The Ford Mill near Lacomb actually caught fire at 2:00 a.m. on August 12, and it was considered a total loss. The mill had been running two shifts six days a week, turning out approximately thirty-five thousand board feet per day. However, no crew had been working on the morning of the fire since it was the regular Sunday lay-off. There was immediate suspicion that the blaze was the work of a firebug. The origin of the blaze in the center of the mill was very similar to a recent fire at the Fir Lumber Company in Sodaville. The Dimension Lumber Company from Ridgefield, Washington, owned the mill at the time. However, the owners were not involved with the day-to-day operations. It was referred to by locals as "Ford's Mill," as it was operated by Clair Ford and his brothers, Cecil and Bernard Ford. Along with Kenneth, Bernard's son, Orvis Ford, was known to be employed there. It was a sizable loss to the community given that its payroll was around $250 per day. The value of the mill was estimated between $5,000 and $6,000. Unfortunately, the Dimension Lumber Company carried no insurance on the plant. As Clair Ford worked diligently to get the Lacomb mill back up and going, the Roseburg project was put on hold.

In the last quarter of that year, America had been experiencing a slight recession. However, on October 24, 1929, the stock market began to show signs of stress when more than 12 million shares were traded on the day known as Black Thursday. Then, on October 29 (Black Tuesday), panic ensued as millions of shares were dumped and the market crashed. Billions of dollars were lost, and thousands of investors lost everything when many stock shares became worthless.

President Hoover tried to keep Americans calm, stating, "Any lack of confidence in the economic future or the basic strength of business in the United States is foolish." However, by 1930, the unemployment rate had more than doubled from that of a few months prior, reaching upward of four million people as America entered the Great Depression.

SOUTHERN OREGON TIMBER

STAVING OFF DEPRESSION

As America entered the 1930s, the grip of the Great Depression was becoming more apparent. While the 1920s were known as a tremendous time of prosperity for many, farmers were under increasing economic pressure. Years of severe drought in the Great Plains were continuing to take their toll. Decreasing food prices also presented quite a quagmire for farmers who couldn't afford to harvest crops. The crops were literally rotting in the field while at the same time Americans were experiencing a shortage of food. America would begin to experience food riots like that of the infamous incident in Minneapolis, Minnesota.

Statistics indicate that during the period of 1929–33, Oregon's timber industry saw a decline in output of over 60 percent. Wages were also significantly decreased, creating substandard living conditions in many logging camps. The industry losses were heavy, but Clair Ford managed to rebuild the Lacomb mill after the 1929 fire and kept the mill running. Kenneth cut cordwood, which he sold for two dollars a load. Often, as was commonplace in those days, he would barter the company's lumber wares for food staples and other necessities.

The announcement by Elmer Giles in August 1930 came as no surprise to Roseburg residents. C.H. Ford would delay the opening of the new mill "until the lumber market justifies cutting." There was some small equipment already in place, but the remainder would not be brought down until the mill was ready to operate. He speculated it would require about two weeks to finish the work, "and the mill would be ready before the logs could be brought out from the woods."

In December 1932, the Bank of the United States in New York City collapsed. With over $200 million in deposits, it was the largest single bank failure in U.S. history. Nearly half of the nation's banks had closed their doors.

In November of that year, Franklin D. Roosevelt had been elected president in a landslide victory. He inherited the Depression at its nadir. Stock prices had reached their lowest levels, while unemployment reached its highest point at 25 percent. There had been several "runs on banks," which led Roosevelt to declare a four-day "bank holiday" in March 1933. Roosevelt moved the country off the gold standard, and eventually, money was channeled into the monetary system through the Reconstruction Finance Corporation, which was established by Congress.

THE KENNETH FORD FAMILY LEGACY

A Change of Scenery

Kenneth continued to work in his father's mills while his sisters, Edith and Lois, worked as teachers in Lebanon. They had managed to save some money over time. With little in the way of work available that summer, Clair urged the three of them to take a road trip to visit relatives and see the country. They recruited a couple more travel companions in Hallie Brown and Sam Hull.

Hallie was born in Red Fork, Oklahoma, on March 17, 1905. After graduating from Beggs High School, she put herself through college at East Central University. She graduated in 1930 at age twenty-five with a major in home economics and a teaching certificate. After teaching for a short time in Oklahoma, she moved to Oregon with her parents. She and Lois became friends while attending the same church and teaching together.

The group pooled their resources and bought a car. They equipped it with tents and supplies. Travel in those days was relatively cheap, and the trip was planned around visits to relatives along the way. When not staying with family, they lodged primarily in auto camps and campgrounds.

The group first set off for San Francisco before heading southeast to Oklahoma and Texas to visit Hallie's family. Undoubtedly, they witnessed

Cross-country road trip, 1933. *Photo courtesy of Allyn Ford.*

the destructive magnitude of the drought, leaving the "dust bowl" effects in its wake. From here, the road led to New Orleans and onward to Sarasota, Florida, to visit relatives of the Fords. Eventually, the party explored the eastern seaboard north to New York City.

On the last leg of the trip, the group made a stop in Chicago for the World's Fair. The fair was named a "Century of Progress" to celebrate the city's centennial. The exhibits spanned over 430 acres on the city's north side along the shore of Lake Michigan.

During this two-and-a-half-month journey, the group experienced firsthand the devastation and misery caused by the Great Depression and its grip on the entire country. The festive atmosphere portrayed in Chicago would have offered a refreshing change for them.

There were a variety of interesting exhibits that encompassed the fair's motto, "Science Finds, Industry Applies, Man Conforms." One was a 1933 Homes of Tomorrow Exhibition, which showcased twelve model homes that displayed new creative and practical building techniques and materials. There were also architectural designs, including a popular twelve-sided "House of Tomorrow."

Hallie had both an appreciation and aptitude for art. The fair featured a world-class art exhibit. Twelve murals painted by Hilda Goldblatt were displayed at the Federal Building. The murals depicted America's influence of power at sea from Jamestown in 1607 through World War I. "Pulaski at Savannah" by Stanislaw Kaczor-Batowski won first prize and would later be unveiled at the Art Institute of Chicago by Eleanor Roosevelt.

The bright lights and enthusiasm portrayed at the Chicago World's Fair offered a glimmer of hope for the future. It was a striking dichotomy to the harsh reality of the plight taking place across America at that time. The exhibits portraying future innovations and ideas may very well have served as an inspiration to Kenneth and Hallie when they returned home to Oregon. It certainly gave the entire group a new perspective on the future.

Notable Changes

Kenneth and Hallie were married on June 16, 1935. Filled with determination, the newlyweds decided to move to Roseburg to complete the mill. There had been, however, some significant changes since the Fords' initial foray into Douglas County.

THE KENNETH FORD FAMILY LEGACY

The Roseburg mill would no longer be called Clair Ford and Son. In 1933, the Dimension Lumber Company had dissolved its corporation. This paved the way for Clair to become the owner of the Lacomb mill. He also obtained the rights to the planer mill in Brewster, which was under lease by Alex Brewster. With the purchase of these mills, Clair had committed to living in Lebanon full time. A 1936 timber directory in the *Lebanon Express* newspaper revealed that his new company was called the Ford Lumber Company. Meanwhile, Kenneth would have the opportunity to complete the construction in Roseburg and, at age twenty-eight, start a mill of his own. He named it the Roseburg Lumber Company.

6
BUCKING THE TREND IN ROSEBURG

By most accounts, starting up a new business venture in the heart of the Depression was a risky proposition. Although government programs had been instituted to lessen its impact, the country still faced much adversity on an uncertain road to recovery with no clear end in sight.

As a visionary, Kenneth Ford looked at things differently. While others struggled to hold on, Kenneth searched for opportunities to forge ahead. It was this same mode of thinking that would serve to propel Roseburg Lumber to new heights in the years to come.

From the beginning, Clair Ford played an influential role in helping to make Kenneth's dream a reality. The timber for the Roseburg mill was cut in Lacomb, and the construction lumber was hauled to the site by trucks. Taking advantage of his experience in working with mill machinery, Kenneth chose to equip the plant with used and salvaged equipment. His sister Lois told that credit was hard to come by. "In those days, no one really had credit…Kenneth had none." Some of the machinery was from his father's mill in Lacomb; the remainder was purchased through Portland junk dealers Sam Schnitzer and Sam Zidell. Unbeknownst to Kenneth, Clair had told the dealers he would back Kenneth on anything he purchased.

In 1936, the Roseburg Lumber Company was officially founded by Kenneth Ford. The mill, which sat at 640 East Second Avenue South, began operations in early May. With about thirty-five employees, Kenneth worked tirelessly to oversee all the company operations. Lois humorously admits that

in the summer of 1937, "I succumbed to the family weakness for sawmilling and inherited the job of…the one-gal office force."

Lumber had been secured in the Lane Mountain area. Jim Marr's family lived off Buckhorn Road: "I remember Ford hauling logs from the mountain on a single-axle Chevy truck." The company also had a logging camp located on a steep section of the Callahan Mountains, near Camas Valley. This timber was accessible via the Coos Bay Wagon Road.

The mill was sparsely equipped with one circular saw, which employee Henry Hall explained sometimes struggled to saw completely through a log, so an axe was used to finish the cut. There were about thirty thousand board feet of lumber sawed daily. Inside, the mill had an edger, two trim saws and

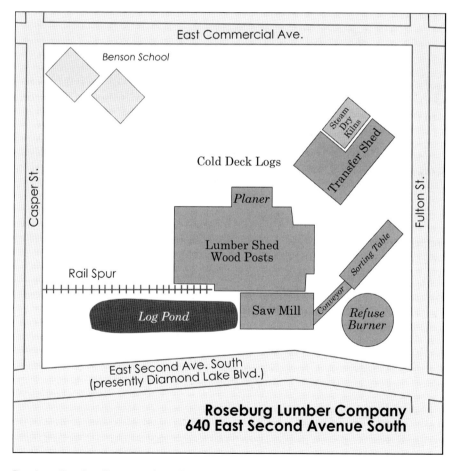

Roseburg Lumber Company Complex. *Created by Amy Goodwin.*

ROSEBURG LUMBER COMPANY

Manufacturers of

Kiln Dried Douglas Fir Lumber

TIMBERS - DIMENSION - R. R. MATERIAL

Telephone 468

Roseburg, Oregon

FUEL for SALE

SAWDUST

Sawdust Burner & Parts

Carried in Stock

SLABWOOD 16 In. / 4 Ft. } Green & Dry

Immediate Delivery -- Phone 468-469

City directory ad, 1948. *Photo courtesy of the Douglas County Museum.*

a carrier. The yard had one solid-rubber-tired lumber carrier. Mill employee Paul Weaver summed it up: "The beginnings were small; they had to be. But every accomplishment must have its beginnings, however insignificant."

Not everyone believed Ford's mill would be successful. When Harry Wesley, who later married Lois Ford, was delivering sawdust and slab wood to another newly established Roseburg business, he asked its co-founder why he hadn't bought a sawdust burner, since it would be easier for him to use. The man replied, "That one-horse, fly-by-night business won't last over a year. Why should I go to all that expense? I'll stay with the wood because I can always have a supply of it."

The wood slabs and sawdust became a hot commodity, as fuel wood for the community was a good source of income for Roseburg Lumber. There were about forty cords of slab wood cut each day and delivered around town by two trucks. In that first year, this side business helped Ford eke out a small profit.

1937 Fuel Wood Prices

Four-foot slab	$1.00 per cord
Sixteen-foot slab	$2.50 per cord
Commercial sawdust	$1.50 per unit
Household sawdust	$2.50 per unit

Making Payroll

Finances were tough throughout the first few years of operation. In addition to the struggles to pay the bills on time, Lois remembered they often were strained to make payroll. Employees sometimes were given half of their pay or asked to wait on cashing their checks until after the company received the proceeds from a sale of lumber. Many area merchants refused to cash their paychecks. One exception was Curly Grimm's Grocery, which would extend a line of credit while holding the checks for collection later.

About once a week, Kenneth would grab a sack lunch and drive to Portland to collect for that week's lumber from his primary customer, Dant & Russell. He would then quickly drive back to get it deposited in the bank before employees cashed their checks.

Lois explained, "The mill provided work for people in hard times. When the company secured new cuttings, I remember Kenneth telling the crew, 'If you are going to be part of this new cutting, you will have to put in two or three days of free time to building a road.'" And so they would. People didn't think much of it. This was the Depression, and their sacrifices would secure them future wages.

Roseburg, a Timber Town?

There was an abundance of untapped timber throughout the Roseburg area, but at this time, it was considered a quiet, pastoral town. The mainstay of its economy was ranching and farming. The *Oregonian* writer George Griffs mentioned that the census takers in 1940 found that "lumbering was of some importance with 37 mills scattered throughout Douglas County, but the town's main thoroughfare, Jackson Street, was populated with more farmers than millmen on a Saturday afternoon."

Roseburg had once been home to about twenty various timber-related mills from the 1870s to 1920s. Most were located in central Roseburg along the railroad tracks. Then things died down considerably. When Kenneth arrived on the scene, there were not many mills. St. Helen's Wood Products was located at 345 Winchester Street. The company made broom handles and other small wood stock. Another sawmill just east of Roseburg, owned by V.F. Sanders, was also turning out lumber and fuel wood.

The Saar Pencil Factory opened almost concurrently with the Roseburg Lumber Company. It was located on the northeast corner of Rifle Range Road and East Second Avenue South. It cut cedar mill logs into slats that were the length of a pencil. In 1938, with twenty employees, the factory was able to manufacture 1,500 gross pencil slats. By 1960, it produced enough slats to make 100 million pencils with a crew of just twenty-five people.

In July 1937, the *Roseburg Chieftain* headlines proclaimed that the two sawmills and pencil factory were an aid to the city's long-felt payroll problem. This problem began when the Southern Pacific Railroad closed up some of its operations in Roseburg as a result of the Natron cutoff. The cutoff bypassed Roseburg, diverting most train traffic from Springfield, Oregon, to Black Butte, California, via Klamath Falls. Travel on the original route was hampered by steep grades and sharp curves around the Siskiyou Summit. The cutoff provided a shorter route with easier grades.

THE KENNETH FORD FAMILY LEGACY

Interestingly, the newspaper predicted that Roseburg could become a major lumbering center in the future. "In my opinion Roseburg is a coming sawmill town," said millman V.F. Sanders. "As it can readily be seen from its location, that it is really the hub of a great timber area which is bound to be tapped sooner or later."

This was indeed the beginning of a rebirth for the timber industry in the area, as Sanders's striking prediction would come to pass within the next decade. George Abdill, director of the Douglas County Museum, reported that, in 1939, there were only 37 sawmills operating in the county, but by 1947, this number would increase to 278. "The harvesting and processing of this 'green gold' earned Roseburg the title of 'Timber Capital of the Nation.'"

OVERCOMING THE ELEMENTS

After establishing the mill in 1936, Kenneth Ford and his small crew would face unique challenges in their day-to-day routine. It often took hard work, determination and working long hours to keep the mill going through the lean years. In a company publication, "A Dream Come True," former employees related stories in a brief history of the first twenty-five years of the Roseburg Lumber Company. Keeping the mill running efficiently often required overcoming the obstacles of both natural and man-made elements.

Water

The Roseburg mill began with a small log pond that was approximately six feet deep. Over time, the pond would fill with mud and debris. On one occasion, the crew planned to gradually drain the pond, but the Cat operator accidentally cut the opening too large. East Second Avenue South was immediately covered with water, logs and debris. Traffic had to be rerouted as Ford and Roy Wilkinson waded in knee-deep water to clean up the street. The flood of water took out a nearby tomato patch and claimed a few chickens.

In another story, employee Henry Hall recalled that during a flood around 1950, the Hinkle Creek cookhouse ran out of food. "So another man and I loaded a pickup with groceries and started for camp. In Sutherlin and east of there, the water came up to the floor boards, so I drove while the other man, with a stick, walked ahead of the pickup to find the road."

SOUTHERN OREGON TIMBER

Fire

The ever-present sparks from saws and equipment combined with the highly flammable property of sawdust and wood created a high risk for fires. On July 3, 1939, when the whistle blew at the mill, the men were told that loggers had reported a fire in the woods near Coon Creek. Without time to inform their families, the men (many of whom had just completed a full day of work) and equipment were loaded into trucks. They were quickly transported to the blaze east of Sutherlin, fighting the blaze for two days and two nights. Hallie Ford and sister-in-law Lois had notified the men's families before arriving on the scene with coffee and sandwiches for the workers. The Fords' infant daughter, Carmen, was also part of the relief crew.

In 1948, a fire broke out at the Roseburg mill. Kenneth Ford fought the blaze with a hose as employees sheltered him from the intense heat with a large sheet of plywood. The fire lasted for about five hours.

Mud

The lumberyard was covered in what locals called "Douglas County Mud." This sticky black mud would settle, forming deep ruts and bogging down vehicles and equipment surrounding the mill. Wooden planks were laid on top of the mud but without gravel. When the rains came, the mud soon oozed up through the planks, resulting in a slippery mess. The lumber carrier would often slide off and get stuck, or the planks would separate and the wheels would get stuck between them.

Paul Weaver explains that in 1939,

> *Mr. Ford had recently purchased a block of timber east of Sutherlin* [Hinkle Creek area], *but the bad weather kept the trucks out of the woods. Calling the men together,* [he] *told them that if two bridges and a mile of plank road could be built, the log trucks could begin to roll six to eight weeks sooner than normal. He also told them he could not pay them for the work but would give them one dollar per day for beans and said he would eat beans too. As he worked side by side with men who rallied to his support, the road and bridges were completed…and work was resumed.*

Dust

Fall through spring, rains created muddy conditions; however, with hot, dry summers, dust could create havoc. Heat could also cause tempers to flare, as was the case for a rancher and his wife who stopped by the mill to complain about the dust from the logging trucks along their road. The rancher soon became irate at what he considered was Kenneth's lack of interest in his quandary, and he took a swing at him. Ford wrestled the man down, pinning his arms in the sawdust. The rancher's wife jumped from the car armed with a flashlight. When the mill superintendent unarmed the woman, the rancher turned his ire on him. Paul Weaver reported, "One good roundhouse by the superintendent and the man found himself in the middle of the street, whence he crawled on his hands and knees to his car and drove meekly away."

A Changing Tide

As the 1930s were coming to a close, Americans were working to move beyond the Depression while looking forward to creating a new chapter in the country's history. The Roosevelt "New Deal" programs were gaining traction, and the overall economy was showing signs of improvement. With rumors of war escalating, the United States began preparations for a second world war. This aided in stimulating the economy. In November 1940, Roosevelt was elected to serve a third term as president.

Always the visionary, Kenneth kept his eye on changes and trends in the timber industry that would present themselves in the future. Over the years, he would often challenge his managers that although they couldn't know when specific events in the marketplace might happen, they needed to be prepared when they did.

Changing Expectations

The rebirth of mills in Roseburg was not welcomed with open arms by some residents. Perhaps they had witnessed the early years, when the mills were started only to be closed down. Maybe they didn't relish the thought of the smoke and soot from the mills. Roseburg had become a sleepy town

of retirees surrounded by pastoral ranches. And with the addition of more mills, residents would be subject to more traffic and the rumbling of logging trucks from early in the morning to late at night.

The city's business sector, however, now saw a potential for growth and revenues in the form of not only timber jobs but timber-related businesses as well. In a 1940 speech by Ford to the chamber of commerce, he made it evident that they were expecting too much too quickly. He laid out some of the obstacles that stood in the way of progress. Ford dismissed the idea of bringing a peeler mill to the area as premature until a sufficient number of mills were established to handle the sawing needed for that type of mill.

He suggested that the addition of sawmills should not be based on their location in Roseburg but rather in the county. He felt the city would derive just as much benefit from a mill located twenty or thirty miles away. Finally, he spoke of the need for trained lumber workers as the key to future operations.

Branching Out

From the company's inception, the Fords worked diligently to make Roseburg Lumber a successful enterprise. They built loyalty with their employees, often paying them before themselves. Much of their earnings were directed back into the company. The Depression taught them the importance of discipline and frugality, which was the means for their survival in the early years. But as the dust began to settle and the 1940s approached, Ford saw the need to refurbish the existing Roseburg mill in order to keep pace with an improving marketplace and the increased demand for lumber. He also began to implement his plans for expansion with a new, modern and more efficient plant in Dillard. The business was moving on several fronts, setting an even more demanding schedule.

Around the mill, Kenneth set the standard for employees with his own work ethic. Earl Plummer commented, "Mr. Ford set a tremendous pace for everyone, doing three men's work—logger, mill manager, sales manager—then expansion, building, always building." Kenneth had now come to the point where he would need to delegate these positions and some decision making to others.

Beginning in the fall of 1939, there were wholesale changes underway with construction and upgrades of the mill. Dry kilns and a machine shop were built. A new office building was added across Diamond Lake

THE KENNETH FORD FAMILY LEGACY

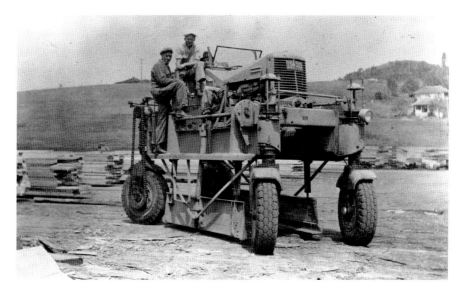

Men on a lumber carrier, Roseburg Lumber Company, 1938. *Photo courtesy of the Douglas County Museum.*

Boulevard. The original office space (which was often referred to as "the shack") became a storage area. Soon came the addition of a new planer and planer mill along with the installation of two large boilers to provide steam for the kilns and additional steam for the mill.

A larger portion of the property was developed for storing more lumber. In the early years, employee Larry Strode explains, "Logs were dumped into the pond with a Mack motor that had no starter and had to be cranked…Logs were pulled into the sawmill by a cable and rolled down to the carriage by hand with the help of a cant hook and a half-moon log kicker. Logs were put in a cold deck by a 9 by 11 steam engine donkey on a skyline." In 1943, the pond, which was 300 feet long by 150 feet wide and held about forty thousand board feet of logs, was nearly doubled in size. The pond then held "about one day's mill cut of seventy thousand [board] feet."

Former CEO/executive vice-president Bill Whelan reflected that the competition in the timber industry had always been about the cost of buying and securing a good supply of land and timber. Unfortunately when selling lumber products, they were essentially a commodity, and the prices became somewhat standardized. So, he said, "If you haven't got it made by the time the logs are in the pond, you are not going to make it at all." To ensure and maintain his timber supply for future operations, Kenneth began a search for a woods supervisor, setting his sights on Glendale, Oregon.

SOUTHERN OREGON TIMBER

GLENDALE

In the 1940s, Glendale was a busy mill town. Historically, timber operators had been plentiful in the area. In fact, one of the first mills there had been built by Solomon Abraham around 1882, long before the town was incorporated. These early mills produced timber for the completion of the Oregon and California Railroad between Roseburg, Oregon, and Redding, California.

In true timber-town fashion, the Glendale Lumber Company constructed a four-and-a-half-mile "V" flume from its Fernvale mill on Windy Creek Road down into the heart of Glendale in 1903. Reaching heights of twenty-five feet, the towering flume carried lumber to what is now called "Dollar Hole" on the north bank of Cow Creek. This location near Brown Street contained a planer mill and railroad siding from where the lumber was shipped.

There were also prime timber reserves west of town near Reuben and West Fork, Oregon. Despite its remote locale, West Fork had been the hub for trails used by local miners. Without roads, supplies were transported on horses and mules.

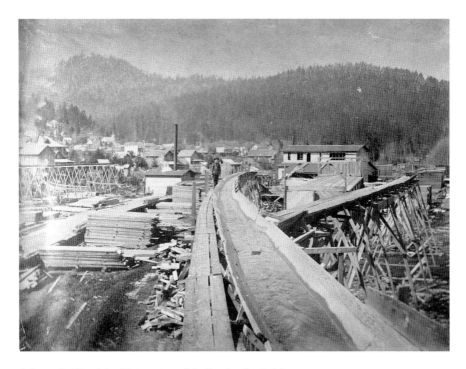

A flume in Glendale. *Photo courtesy of the Douglas County Museum.*

THE KENNETH FORD FAMILY LEGACY

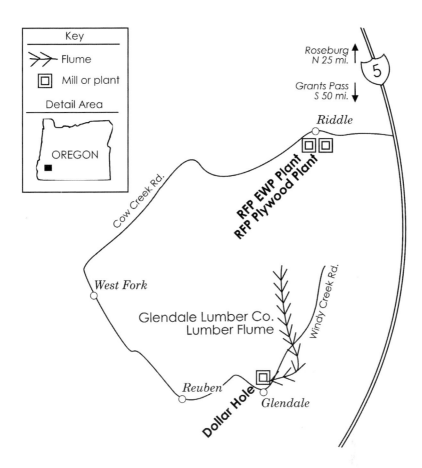

Map of Glendale area. *Created by Amy Goodwin.*

Author Susan Waddle told that a train siding was established in West Fork as early as 1882. There was a depot and residence building along with a turntable that allowed engines to turn around. This twelve-mile stretch of rail had been used by the Campbell & Swigert mill located above the town. Lumber was conveyed downhill through a dry chute to the railroad below. At the time, the only access into Rueben and West Fork from Glendale was via rail. In addition to mines, sawmills and logging camps continued to spring up, and the town established a hotel and store. In 1920, the West Fork census listed 118 residents.

In 1930, S.K. Ingham and his associates acquired a controlling interest in the Glendale Lumber Company. Eventually, the name was changed to the

Ingham Lumber Company. Ingham was purchasing timber all around the Glendale area, including near West Fork. In 1934, he hired Herman Aydelott to assist in running his expanding operations. During his employment, Aydelott was spread thin overseeing operations in multiple logging camps. With its vast reserves of timber, he spent a good deal of time in West Fork.

Ford's Recruiting

In 1942, Ford placed an employment advertisement that led him to Herman Aydelott. At that time, he was still working as a foreman for the Ingham Lumber Company, but he was looking for a change of scenery. He explained, "Ingham was a funny guy to work for…I hardly ever saw him." They would pass notes as correspondences; even time slips were conveyed through a drop box downstairs below Ingham's upstairs office.

Aydelott heard from friends that a man was in town asking about him. He had no idea who it was until he interviewed with Kenneth Ford. The inquisitive man was Kenneth's dad, Clair Ford. Upon his accepting the job, Mr. Ingham told him, "That Ford is just running on a shoestring, and he won't last six months. A job is waiting for you whenever you want to return."

Clair Ford Retires

The timeline for Clair's visit to Glendale was well within reason. In June 1941, C.C. and Bertha Low bought his Lacomb mill and the rights to the lease on the mill in Brewster. When the papers were officially filed in 1942, Clair retired—so to speak. Bernard Ford remained as the mill superintendent.

On July 31, 1946, there was a fire at the Brewster siding mill. Several railroad cars and their loads of lumber were destroyed along with a considerable amount of lumber on the dock. About half of the green chain shed was burned. About that same time, Ray Townsend helped to tear down the Ford mill in Lacomb. In 1996, the floodwaters on Beaver Creek washed away the dyke on the millpond. All that remains today is the cookhouse, which was converted into a residential home.

THE KENNETH FORD FAMILY LEGACY

AYDELOTT'S TENURE BEGINS

An adequate timber supply to meet the increasing lumber demands was the last and perhaps largest piece of the puzzle to solve before the expansion of the Roseburg Lumber Company could become a reality. The idea was to shore up its current woods operations and then look to find additional timber.

In 1942, Herman Aydelott began the job with Roseburg Lumber as woods superintendent. During this period, the bulk of the timber was being logged near Mount Scott at Hinkle Creek. Between Sutherlin and Hinkle Creek was the unincorporated town of Nonpareil. The town sprang up with the Bonanza quicksilver mine in the 1860s. In 1881, the town was platted but never really developed. In the 1900s, with the arrival of logging camps nearby, the town became a bustling place.

Up to this point, Ford had had a hand in virtually every business decision regardless of how large or small it seemed. He was just acquainting himself with the idea of delegating authority. So the men on the crew were a bit skeptical when Aydelott, a self-starter, immediately used his road-building experience to begin improvements on the plank road at Hinkle Creek without conferring with Kenneth. The roads were indeed in constant need of repairs. Gyppo logging truck driver Gerald Bacon remembered, "You had to drive very careful on those roads. They were rough and often very steep and slick."

Herman Aydelott saw this first hand. "I had to send men down every morning to work on it…to put boards in or something and I was getting tired of it, so I changed the road." When Kenneth arrived, he asked, "What in the world are you doing up there?" Aydelott responded simply, "I'm changing it." Ford walked up there and looked around awhile and never said anything, which employees of Ford knew meant it was OK with him. If Kenneth hadn't liked it, he would definitely have let him know about it!

Aydelott explained that the biggest challenge was getting the timber cut, as all falling and bucking was done by hand. The war brought additional problems. "When war was declared, our woods crew changed overnight. Most of our experienced men were drafted into the service. A very few of our key men were deferred." With a shortage of experienced loggers, there was an increased competition between companies for workers. Often, the bus that brought workers from town arrived empty.

Ford's experience and penchant for hard work was a huge asset in the woods. Aydelott explained:

SOUTHERN OREGON TIMBER

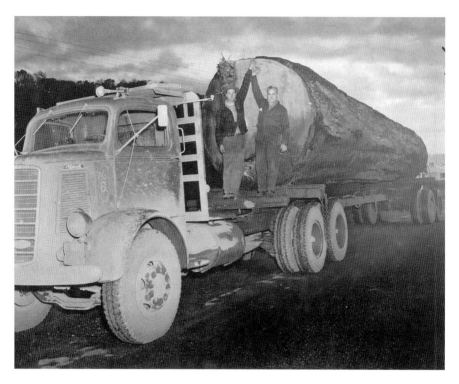

A log taken near Hinkle Creek. *Photo courtesy of Allyn Ford.*

Many times Mr. Ford and I would set chokers or whatever job came our way. Mr. Ford would come out and do a job where we were shorthanded. He would run a donkey, punk whistle or set chokers. The main thing he liked to do was loading. When the cook would go into town and find too much to drink, Mr. Ford and I would come down after work and cook supper for twenty-five to thirty men. We would sometimes call on Mrs. Ford or Mrs. Aydelott to help us out until we could find another cook.

The original logging camp at Hinkle Creek had bunkhouses for lodging the men and families. A cookhouse was constructed on site. The cook had only a wood stove on which to prepare meals. In the summertime, the nearby spring would go dry. This resulted in added frustration for the cook and dishwasher, as they would have to carry water from a creek. The shortage of water also meant a lack of showers, causing many of the families to move out of the camp.

THE KENNETH FORD FAMILY LEGACY

The constant challenges of day-to-day operations are part of what began to separate Kenneth Ford from the pack. Hazel James told that Ford was already a determined man. These setbacks and challenges only made him more determined than ever. She said, "Things were always done. The challenge and determination I saw in my employer made me more determined to get along and do the best of my ability."

By the mid-1940s, improvements were being made to the logging facility as gravel roads replaced the plank roads into camp. A creek on the mountain was tapped to provide plenty of water for all seasons. And new electric lights brightened everyone's spirits around the camp.

7
WORLD WAR II

On September 1, 1939, Germany invaded Poland. This offensive was considered the official start of World War II. As a precautionary measure, the United States implemented its first ever peacetime draft. The treasury issued defense bonds in preparation for what seemed inevitable—entering the war in Europe.

On December 7, 1941, the surprise Japanese attack on Pearl Harbor thrust the United States into the war. The defense bonds then became known as war bonds. As men were drafted into the war, women entered the workforce in record numbers. The government stepped up production in factories for the manufacturing of war materials.

Providing for the military effort resulted in the rationing of food and other supplies. Among the items rationed were gasoline, fuel oil, typewriters and rubber in the form of tires, garden hoses and raincoats. The *United Press* warned that America could expect a shortage in nylons until late 1947. Coupon books became a part of everyday life. The steel industry stepped up production while scrap steel and iron became highly sought-after commodities.

WEST COAST LINE OF DEFENSE

After the attack on Pearl Harbor, the western coastline felt an up-close and immediate vulnerability to the possibilities of further Japanese aggressions.

Truck driver Gerald Bacon said that within days after Pearl Harbor, the hills in western Oregon "were crawling with military personnel. They told us to carry guns." Bacon said he carried a rifle. Volunteers of the Ground Observer Corps recorded the make and identity of aircraft in the area. The military worked with the Coast Guard to patrol the coastline and used jeep patrols along the beaches.

Japan's military posed several threats to the Oregon coastline. Japanese submarines were located at several strategic points along the western coast. In June 1942, a submarine surfaced and fired seventeen shells at Fort Stevens near the Columbia River.

Mountaintops and Forest Service fire lookouts were patrolled night and day to watch for enemy aircraft and balloons that were released by the Japanese military. The seventy-foot-high military balloons were filled with hydrogen and carried bombs—many of which were incendiaries. They were meant to explode on impact and start forest fires. There were over thirty thousand of these balloons launched over a five-month period beginning in November 1944. Considering the wetness of the Northwest forests, this offensive was not very successful. There were forty-five balloon incidents in Oregon, including one at a picnic area on Gearhart Mountain near Bly, which caused the death of five children and one adult.

Rationing

A major part of the war effort was the rationing of consumer goods, as the needs of civilians took a back seat to those of military operations. Although considered crucial to the war production, the timber industry was also affected by the rations. Rationing books and tokens were issued to each American family.

At the mill, it became important to plug and patch tires to extend their usage. Due to gas rationing, employees would catch a ride on company trucks whenever possible. Many loggers lived in cabins at the camp. At this time, much of Roseburg Lumber's timber was being harvested from the Mount Scott/Hinkle Creek area outside Sutherlin, with about seventy-five men working there.

The food rations changed over time depending on market conditions and what was in short supply at the time. The idea of the rationing books was to ensure that everyone got their fair share. No one was allowed to purchase

more, even if they could afford it. Needless to say, food was often hard to come by, especially in the logging camps.

Hallie Ford's love of gardening would have a big impact on the quality of food in the camps. Behind the truck shop at the mill, she planted a garden near an existing cherry tree. She and mill employee John Walker canned hundreds of quart jars of food to serve at the camp during the wintertime. Employee Hazel James told that the cooks prepared delicious meals, especially their homemade pies. This further demonstrated the resourcefulness and dedication of the Fords to meet the needs of their employees while continuing to build their business.

Ultimately, as the war lingered on, the logging camps would get more food points. The Office of Price Administration made an exemption to the rationing of food for jobs that required high caloric intake. They announced, "Meat fat points and sugar allowance will be stepped up

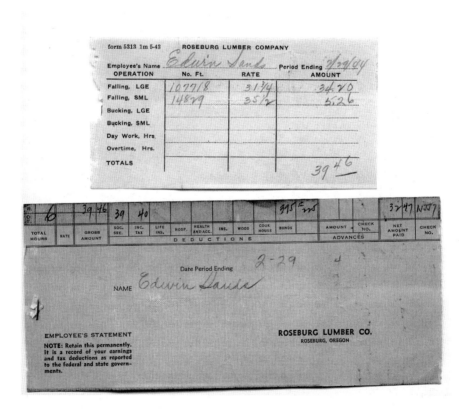

Edwin Sands's pay stub from Roseburg Lumber Company, 1944. *Photo courtesy of Karen Bratton.*

to meet greater calorie needs, based on the degree of isolation, the availability of non-rationed foods, refrigeration and the other conditions under which they work."

WARTIME FOR THE TIMBER INDUSTRY

Roy Wilkinson, who drove Roseburg Lumber's wood truck, explained, "Shortly after Pearl Harbor in 1941, I recall the day when the mill whistle blew. That meant all men stopped work. Mr. Ford called all of us together, and then Sergeant Paul Morgan told us that each man in the crew was deputized and given authority to protect this important war industry. It was then we realized the importance of this plant to our government." Lois Ford was tasked with the job of filling out forms to enable workers to avoid the draft.

Some men in key positions were deferred and remained at their jobs. But many of the men were called to active duty. Members of the Forty-first

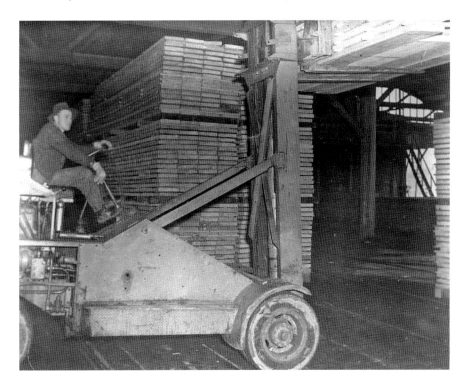

Roseburg Lumber sawmill interior, 1940. *Photo courtesy of the Douglas County Museum.*

Infantry Division out of Roseburg, while stationed far away in the South Pacific, were delighted to see the Roseburg logo stamped on the wood products that were delivered to them in combat. For soldier Jim Marr, it was like getting a message from home.

As was the case in World War I, the timber industry would be called on again to supply the government with large quantities of lumber. The National War Production Board (WPB) awarded Boeing over $1 billion in contracts. The Renton and Seattle plants produced over eight thousand aircraft during the war. Most were B-17s or B-29s. Spruce was a favorite wood for airplane frames, while fir was used in shipbuilding.

The Seattle Tacoma Shipbuilders built an array of war vessels including escort carriers, destroyers, minesweepers, floating dry docks and even wooden tugboats. At the Lake Washington Shipyard in Houghton, workers repaired ferries and other merchant vessels for the navy.

With new commercial standards set in 1938, plywood became an essential product for the government. Plywood worked well for the quick assembly of barracks. The navy used plywood PT boats, and the army crossed the Rhine River in assault boats built with plywood. During the war, the military expanded the uses of plywood for accessories, everything from crating to lifeboats for many ships. The government's experimentation with plywood and its uses would have a profound effect on the timber industry in the future.

Lumber was also hauled out of southern Oregon for the "Atomic Energy Works" project in Pasco, Washington. Bacon said, "The government was buying loads of sawn lumber from a mill near Oakland, Oregon. At the time, no one knew what it was being used for."

The War Department was building nuclear reactors at a processing center at the Hanford Nuclear Site where the department could extract plutonium from uranium for atomic weapons. In August 1945, the Hanford atomic bomb was dropped above Hiroshima, Japan.

A Combined Use of FDR's Alphabet Soup Agencies

Roosevelt instituted many "New Deal" programs during the Depression, a concept that carried over nicely into World War II. While most programs were set up for a distinct purpose, it was common for them to be used together on unique war projects. In the case of Young's Bay Lumber

Company, the War Production Board (WPB), whose primary function was to convert civilian industry to war production, worked with the Defense Plant Corporation (DPC), which loaned money against the future production of machine tools. This was then ultimately financed by the Reconstruction Finance Corporation (RFC).

The importance of the lumber in southern Oregon dictated a decision by the WPB in conjunction with the DPC to invest in placing a specialized sawmill there. While most projects were smaller in scale and costs, this $650,000 deal was the first of its kind in the Northwest. The government contracted with Charles Miller, who owned the Young's Bay Lumber Company located in Warrenton, Oregon (in the northwest corner of the state). According to the deal, Miller would move his machinery and equipment to a new facility on the outskirts of Roseburg, Oregon. The government investment would be for wartime purposes only; afterward, the remaining portion of this investment would become the responsibility of the Young's Bay Lumber Company in the form of a loan.

Situated near the desired timber, the mill was designed to cut one-inch lumber for the use of crating war supplies. To help with lodging the nearly two hundred employees, the contract called for building fifty company houses. According to the *West Coast Lumberman*, signs were placed throughout the sawmill that demonstrated beyond a doubt the government's role in the project:

> *This is a GOVERNMENT PROJECT. All Buildings, Machines,*
> *Tools and Supplies Are the Property of the United States Government.*
> *Remember We Are Building A War Plant.*

The plant began operations in January 1944; however, by September 1945, the government had ceased its operations there. With his health deteriorating, Miller soon put the mill up for sale. The U.S. Plywood Corporation then purchased the company.

The American war efforts had paid off, and World War II was coming to a close. On April 30, as the Russian forces were closing in on Hitler's underground bunker in the Reich Chancellery Building, Adolf Hitler killed himself with a pistol shot to the right temple. The German army surrendered to the Allied forces on May 7, 1945. Japan surrendered on September 2, 1945, officially bringing an end to the war.

SOUTHERN OREGON TIMBER

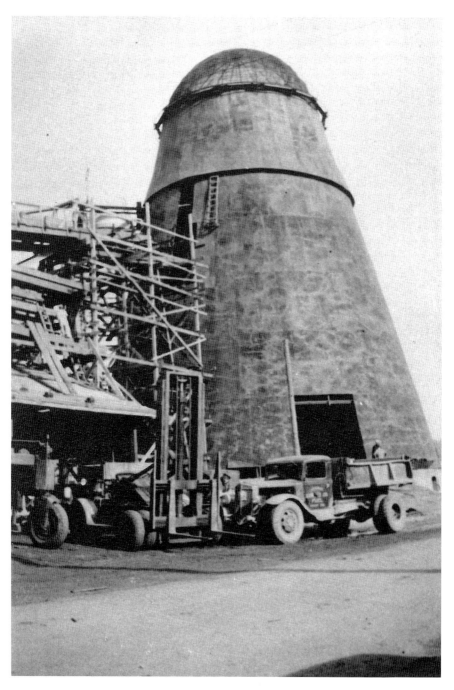

A wigwam burner at Roseburg Lumber, early 1940s. *Photo courtesy of Allyn Ford.*

THE KENNETH FORD FAMILY LEGACY

A New Venture in Dillard

Kenneth Ford was awarded $43,500 in August 1944 by the WPB to use toward the building of a sawmill in Dillard. The preparation and construction on the Dillard property had actually begun around 1939. Foreman Lee Williams said, "The first order of business had been to build a tool shed and lay out the location of the mill." When the war was coming to a close, Ford's crews were completing the construction of the millpond, loading docks, planer shed and a larger, more efficient sawmill.

It was the fall of 1945, and with a victory by the Allied forces in World War II, a newfound confidence was emerging throughout America. In hindsight, it was evident that the wartime economy had served as a catalyst for the economy. Wholesale changes were in order for America. The visionary Kenneth Ford also had a strategy in place to take Roseburg Lumber to the next level.

8
POSTWAR BOOMS AND EXPANSION

A renewed hope for the future led to a couple of significant changes in the demographics of America. The "baby boom" began in 1946 with nearly 3.5 million babies born that year. The spike in the childbirth rate continued through 1964. With these growing families came a need for larger, more spacious homes, which led families to shift from urban areas into the suburbs. This "suburban boom" became popular with the availability of cheaper land outside the urban areas. This led to the growing trend of families owning a home on their own lot.

Returning soldiers were eligible for GI bill loans to use for home purchases, and the robust economy made access to achieving the American dream easier. The suburbs represented an increase of the middle class in America. These booms led to the mass production of houses, which would have a lasting effect on the country and had an immediate effect on the timber industry.

The *Oregonian* stated:

> After World War II, a U.S. housing boom created a demand for more building materials, and Congress supported increased road building and logging in federal forests. In 1945, [in Oregon] fewer than one log in six came from federal forests, and only 50,000 woodworkers were employed. Only five years later, jobs had surged to 78,000, and output skyrocketed as mills ran at breakneck speed to keep up with the ex-GIs who married and needed new housing. About one log in five came from federal land.

Years of active logging had resulted in a diminished supply of mature timber on private lands. These shortfalls led to an increased value and more costly timber for the industry. Lumber operations began to scramble to maintain adequate timber supplies for their mills. They began to shift their focus to county and federal timberlands.

Timber Acquisitions

In the early days, Kenneth was cutting government timber or somebody else's timber, not his own.
—Frank Spears, Ford's attorney

Realizing the importance of owning their own timberland, Kenneth and Hallie had begun to acquire small tracts of private timber over the years in a piecemeal fashion. In the late 1930s, Kenneth Ford was cutting timber east of Sutherlin at Coon Creek and Hinkle Creek. At the time, timber in this area was predominately owned by the Roach Timber Company out of Muscatine, Iowa.

William Roach, owner of the Roach Timber Company, had begun to buy land in Douglas County in March 1906. Much of the land in the Mount Scott/Hinkle Creek area was purchased in January 1911 and October 1915. He also obtained land from the sale of the Oregon and California Railroad Company lands. Over all, the company was reported to have over 55,400 acres of timber holdings. The Roach family was also involved in several timber-related industries in Iowa and Kansas City.

They maintained a local office inside the Sutherlin Lumber Company, which was located at the junction of Front Street and Everett Avenue. Roach built a railroad track from the "Roach Unit" into Sutherlin to transfer timber to the Southern Pacific Railroad's main railway. The company also had ambitious plans to build a large sawmill in Sutherlin. In August 1916, the *St. Louis Lumberman* reported on the mill and the company. It estimated the mill would cut 200,000 board feet in ten hours or 400,000 board feet of lumber per day when utilizing day and night shifts.

However, in December of that year, William Roach passed away in Chicago, and the large sawmill never materialized. The Roach Timber Company maintained its presence in the area, but it shipped most of its timber out to the Woodard mill in Cottage Grove, Oregon, and on to mills

in Springfield, Oregon. The company halted further expansion in Oregon while concentrating on its operations in the Midwest.

In 1948, the Roach Company announced it was selling its Mount Scott timberland holdings, presenting the Fords with an opportunity to purchase a sizeable amount of this acreage, which was adjacent to where the bulk of Ford's logging operations had been located up to this time. After years of putting money back into the company and living low to the ground, the Fords now had a chance to secure adequate timberlands to help maintain and support the company's growth in the future.

However, despite the favorable location east of Sutherlin, spending this sizable amount of money was still a gamble for the couple, as they had recently invested a large amount of capital on the construction of the new sawmill in Dillard. This mill had opened in February 1947, but it would take time for the plant to run at full capacity and create a stable revenue flow. Ford had logging camps near Olalla and Rice Valley and at Reston Mountain as well, but he realized the importance of owning and establishing a sustainable yield of timber to feed his growing operations.

In the end, it was a deal they just couldn't pass up. In two separate purchases, they bought 13,820 acres of timberland from Roach. These deeds were settled under Kenneth and Hallie Ford's names. "That's where my father really made it," explained Allyn Ford. "He bet the farm, and it was one of the big keys to helping this company get on its feet. After that, the business really began to establish itself."

Power Saws Introduced

It is impossible to say with certainty when the first chainsaw was invented. By the 1920s, there were many manufacturers laying claim to the first model. There were several prototypes that were hardly practical for use in the woods. In 1926, the "Cutoff Chain Saw" was patented by German engineer Andreas Stihl. Early on, the saws weighed about 145 pounds including bars and chains.

In 1947, all of the falling and bucking for Roseburg Lumber was done by hand. It became the first company in the region to introduce power saws to its operations near Mount Scott. After the men inspected the saws, surprisingly, none of them wanted to use them. Joe Danchok, who lived with his family at the nearby logging camp, said the men were afraid of the saws as their speed

could cause injuries. In the fallers' opinion, the biggest drawback was the noise, which would make it hard to hear them signal "TIMBER!"

Danchok explained that technology would win out and effectively cut down the time for falling and bucking trees. "In 1942, it took four men to fall and buck forty thousand feet, at a salary of eighteen dollars each day. In 1961, two men [could] fall and buck sixty thousand feet, with wages of forty-two dollars per day."

The introduction of power saws came at a time when Walter Durham of the Industrial Relations Committee reported that Douglas fir loggers were earning $1.87 per hour in August 1947—this was an increase of 16 percent from a year earlier. Labor dollars were saved by a reduction of men in the woods.

Fire Damage in Roseburg

On Saturday, May 22, 1948, a fire broke out in the heart of the Roseburg mill. It destroyed two dry kilns, two lumber carriers and over one million board feet of finished lumber. The blaze also caused extensive damage to the green chain and docks. The planer shed and mill received partial damage as well. After fighting the fire firsthand, Kenneth and the crew immediately switched gears into the recovery and rebuilding process. After working around the clock for four days and four nights, they managed to get a limited expanse of operations up and going again. However, with a more modern mill and plywood plant running in Dillard, the company closed the Roseburg mill in October 1952. The next year, it was dismantled.

Logging in the Sutherlin District

During this time, the area off Nonpareil Road remained an active place for logging. According to logging operator Dan Keller, there were countless gyppo logging outfits in and out of the region, many of which had come down from Washington State. There were some permanent camps established as well. In 1946, the Rock Island Lumber Company employed a crew of eighty-five men at its logging camp that sat near the junction of Nonpareil and Hinkle Creek Road. Farther east, Smith Woods Products employed

SOUTHERN OREGON TIMBER

approximately forty men at its camp near the old Hawthorne School site. Weyerhaeuser, who also purchased a sizeable amount of timber acreage from the Roach Timber Company, took over the Smith Woods camp from 1949 until 1961.

Keller first met Kenneth Ford in 1949. His family had been involved in logging in the Upper Peninsula of Michigan before he moved to southern Oregon. He explained, "When I arrived here, I went to look for a job out in the woods near Sutherlin. Someone said, 'That's the Ford bunch over there.' They were in the process of closing up their camp [Hinkle Creek]…I saw three men standing there; two were wearing suits and neckties and one man had on a greasy old pair of coveralls. I thought Mr. Ford would be one of the two well-dressed guys, but he was the one in the greasy coveralls. Hiring

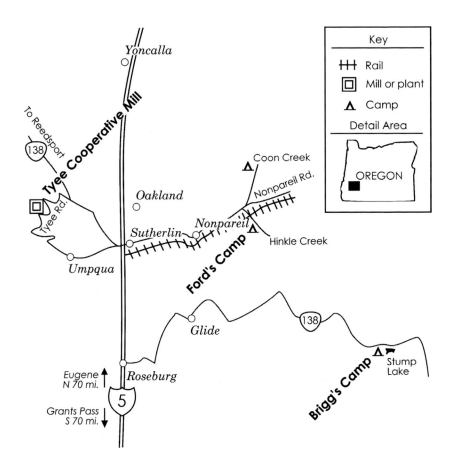

Map of Sutherlin/Tyee. *Created by Amy Goodwin.*

was not his forte back then, and he didn't hire me." Dan instead worked on Rock Island hill for a gyppo logger. He then moved to his present locale in Roseburg, where he established the Keller Lumber Company in 1953.

He told that Sutherlin, Oregon, at that time was a very industrious town. "It looked the same at two in the afternoon as two in the morning. Many of the restaurants and stores remained open for loggers. Several taverns catered to the lumbermen—Jugs Club and the Pastime Tavern were well known establishments," Keller recalled.

One of the region's largest employers was the Martin Brothers Container and Timber Products Corporation, out of Toledo, Ohio. Its plant was located just south of Oakland, Oregon, between Old Highway 99 and Stearns Lane. The company produced shipping containers. In the beginning, these containers consisted of nailed wooden boxes and barrels, but they evolved into wire-bound shipping containers. At the height of operations, the company had over eight hundred employees on its payroll.

With its location on the Southern Pacific Railroad's main route, Sutherlin had mills of all sizes scattered around the town. Timber conglomerates from Springfield and Portland, Oregon; Sacramento; and as far away as Albert Lea, Minnesota, opened plants there. After selling their interests in the Tyee Cooperative Lumber Company, Sid Leiken and Ted Hult established the L&H Lumber Company on West Central Avenue.

TYEE FOREST COOPERATIVE LUMBER COMPANY

Directly west of Sutherlin, Oregon, Tyee Mountain dominates the landscape where the North Umpqua River snakes its way westward toward the Pacific Ocean. In 1859, Jesse Clayton moved from Coles Valley to become the first white settler in the area. He built a log cabin in what was called Wolf Valley. Later, Ewing Powell homesteaded in the lower end of the valley and eventually set up a new postal route between Umpqua, Oregon, and the post office, which was in his home. The Postal Department officially named the new office and subsequently the community it served "Tyee." *Tyee* is actually a Chinook word meaning "chief," "big shot" or "great among his fellows." Author Stewart Holbrook further explained, "A tyee logger is head of a large logging operation."

In 1943, Sidney Leiken and his wife, Thora, joined Ted and Paul Hult and others to begin building a forest cooperative outside Tyee in Wolf Valley. The mill eventually became part of a sustained forest cooperative

agreement. In early 1944, the Sustained Yields Management Act was authorized. Alfred Wiener of the United States Forest Service described this arrangement: "Private forestland, of one or more owners, and [government] land are joined in one jointly managed unit." Although the exact terms for Tyee are not recorded, the purpose was to promote lumber production and employment for local communities.

The timber for the cooperative was obtained from Earnest Short with the balance on a sustained government contract. The group erected a small community in the forest, which initially included about fifty houses for private and government employees. According to area resident Larry Leonard, whose family operated mills in the area, many of the houses were sixteen- by ten-foot bunks. Later, additional five-room plywood houses were added.

The community was known as Tyee Camp and received mail sent to that address. At its peak, there were about thirty-eight families with about thirty school-aged children living there. In addition to a general store, there was also a semiprivate schoolhouse. A blackboard and other supplies were furnished by the Oakland School District. According to author Harold Minter, "A man named Spivendel taught the school until 1948, when he died from a heart attack. Mrs. Thora Powell began teaching at the school the same year." Early on, attempts were made to send the older school students to Oakland, but the roads were too bad.

Sidney Leiken was born in Connecticut. He traveled out west during the Depression as a member of the Civilian Conservation Corps. He was an experienced logger and sawyer; he served as the Tyee mill superintendent. The backflow of a dam on Wolf Creek created a log pond. Sawdust and wood slabs were burned to produce steam, which was used to provide electricity for the mill. At the close of the war in 1945, the mill was sold to Meyers and Sons out of Burlingame, California. James Evans was hired as the mill's manager while his wife ran the store.

The area was known to have good timber, which had caught the attention of Kenneth Ford. With the completion of his Dillard mill in 1946, he was looking to add to his current timber supply. On May 23, 1950, the Tyee mill burned, after which the Meyers family put the lumber company and its timberland up for sale. When Ford heard the news, he called in his woods superintendent, Herman Aydelott. The events that ensued made for a rather humorous story depicting Kenneth Ford's drive and instincts.

Aydelott recalled, "Kenneth called me in and said, 'Why don't you take a day or two off and go look at that?'" Aydelott told Ford that he didn't think

it was a good idea at the time. He said, "I can't get in there. It's all dirt roads, and it's been pouring down rain." Most rational men would have concurred with this reasonable statement, but Kenneth was driven and realized the importance in obtaining the timber. He briskly replied, "Do what you can about it." Herman continued, "So I took my jeep and went down there and got stuck and then had to have somebody pull me out." Still determined, Kenneth sent Aydelott back. This time he explored the burned-out mill and some of the timber on foot. After some deliberation, Kenneth purchased the burned-out milling operation and its timber.

Ford hired Roy Johnson to bring his portable mill to Tyee and cut up the surplus logs. He then sold the buildings to Robert Minter for salvage while retaining ownership of the valuable timber acreage. After the fire, most families began moving away, and the school closed. It soon became a ghost town. Minter had the cabins dismantled in order to use the lumber in another area.

In 1952, George Bryan began working for Roseburg Lumber in Tyee bucking timber. Although his paychecks came from Kenneth, he worked under the supervision of Clair Ford. His employment in Tyee would give George the distinction of having worked for Clair, Kenneth and eventually Allyn Ford before he retired.

Clair had officially retired and bought a ranch near Horsefly, British Columbia, but he continued to make his way back to southern Oregon from time to time. Now, however, the tables had turned since the Lacomb days, and it was Kenneth finding work for his father around the mills.

Keller remembered that Clair was a very personable guy, and when he was in the area, they used the same barber in Roseburg—Walt Good. Early on, Good's barbershop was located at 135 North Jackson Street. He would later move into the Valley Hotel at 303 North Jackson. Clair enjoyed spending free time there talking shop with the guys.

THE FORD POND IN SUTHERLIN

In order to keep a continual flow of timber for his mills during the winter, Ford decided to build an additional pond for storing timber. He recruited surveyor Roger Gee to locate a suitable property near Sutherlin. Gee found property that contained marshland that looked ideal for the pond. Kenneth's nephew Wes Sand explained that when they agreed to take a look at it, Ford

asked Gee to pick him up at his house in the morning, as he didn't want people to recognize his vehicle and know he was looking at the land.

Gee picked Ford up early in the morning and the two proceeded to the property. When they arrived, Kenneth realized that, in his haste, he had forgotten his boots and was wearing bedroom slippers. Not wanting to drive all the way back to the house, Gee carried Kenneth piggyback around the entire 192-acre property so he could get a closer look. What a sight that must have been as the two attempted to remain incognito!

Ford bought that property and built what is still referred to as Ford's Pond. Employee Stan Cornutt explained, "The Sutherlin pond was used for storage [for much] of the Tyee timber. Around the first of November each year, the logs would be removed and hauled to various plants, and the dumping would start again in the spring to refill the pond for the next winter…Shortly after, we built a large pond near Dixonville."

Public Timber Acquisitions

The Depression and the war years had taken their toll on the timber industry. There was a considerable amount of reclaimed timberland due to delinquency of property taxes, so the government and local municipalities looked to sell these timberlands. In the late 1940s, the National Forest Service held public auctions in the old Federal Building in downtown Roseburg.

Ed Erickson was a timber cruiser for Nordic Veneer. His sons John and Steve would often walk the properties with him. John explained, "There were usually five to eight units to be auctioned off within a given plot. Most plots didn't have roads to the timber so the Forest Service used square and triangular markers to signify both where the road would be and to mark the boundaries of the timber units. The cruisers would identify the different species of trees and calculate the board feet of timber they would produce. Another consideration was the costs of building the road. They would weigh these against the government's appraised price on the timber and formulate a bid price for the auction."

The cost for Forest Service lands was relatively cheap compared to buying private timber, so over time, these auctions became competitive. There was, however, a stipulation that the buyer have the proven availability of funds to build the roads. This could be secured through a bond company or cash reserves. The stipulation was necessary, as it could require a considerable

outlay of time and money for timber outfits before they could begin harvesting the timber.

Kenneth Ford had made his first foray into buying government property in 1937, when he purchased a forty-acre timber tract from the BLM in Linn County, near his father's mill. Douglas County was now beginning to hold auctions on its reclaimed timberlands. Although Ford worked long hours, he was kept abreast of upcoming auctions and land sales by his friend Bert Lawrence, who was serving as county clerk. This enabled him to buy repossessed timber through the county for a little as two dollars an acre.

The Gambler

Kenneth Ford wouldn't spend a dime at the tables or slot machines in a casino, but in business, he gained a reputation as being somewhat of a gambler. His methods, while sometimes unorthodox, were, quite simply, effective. In the early 1950s, despite the previous booms in housing, the timber markets were beginning to soften. Retired CFO Jack Snodgrass revealed a story on timber acquisitions that displayed Ford's business style and what set him apart from much of the competition and helped to make him a success.

When Snodgrass began as an office manager with Roseburg Lumber, he discovered the company still had two payments remaining on a ten-year loan from the county. When asked, Kenneth told him that around 1950, the residents of Douglas County were putting pressure on the county commissioners to auction off the timberland that had been repossessed for nonpayment of taxes. The land had been off the tax rolls for years, and the people wanted them sold to create revenues from property taxes.

Soon, the county commissioners announced the sale of about sixty thousand acres of timberland, putting them up for bid at 2:00 p.m. on a certain day on the county courthouse steps. When that day came, Ford was the only one present and, therefore, made the only bid, which was quickly accepted. While they were in the office filling out the paperwork, the clerk asked Ford, "How would you like to pay for this?" He replied, "I don't have the money now, but if you'll give me some time I can pay you." The county gave him a ten-year, low-interest rate loan with no money down and a payment due once a year.

There were many potential bidders who could have benefitted from the timber but probably stayed at home that day due to lack of funds. Kenneth,

sensing the importance for the commissioners to sell this property, saw this as an opportune time to increase his timber holdings, so he took a long shot. His timing was perfect, and he was now purchasing a sizable amount of needed timber with low-interest financing.

The Barbershop Quartet

In a timber town such as Roseburg, a common place to catch up on the local news or what might be defined as "gossip" was the local barbershop. After Kenneth's purchase from the county, the consensus was that he was crazy and that he would go broke. They figured it would cost him thousands of dollars just to cut and remove the timber, and currently it had very little value.

A few years later, the doubters would return with full voice. As the downturn in the market deepened, Snodgrass explained, "Everyone was cutting [timber] and there were logs available everywhere. You could buy them for a song and they would sing it to you!"

Kenneth scraped up all the extra money he could, and while the others were anxious to sell, he was buying nearly every truckload that pulled in. Word got out, and soon his yard was filled with logs; huge cold decks filled the yard to capacity. The town was abuzz but not for long. Ford bought these logs delivered to the yard for around ten to eleven dollars per thousand board feet. Within a couple of years, he was realizing over fifty dollars' profit per thousand board feet as the market came back.

There is a difference in a businessperson who looks at the short-term cost structure and weighs his options on the figures of the day. Ford was looking years ahead, first at that old concept of securing a steady timber supply, and secondly, he realized the market was cyclical and would recover, making the timber more valuable. For Kenneth, these deals made all the sense in the world, and he made an excellent return on his investments. Snodgrass recognized this as a pivotal point for the Roseburg Lumber Company.

Family Time

During this flurry of activity, Hallie and Kenneth were also busy raising a family. The family blended in well within their quaint suburban

neighborhood in Roseburg. With Kenneth's long hours at the mills, Hallie looked after the household duties and, for the most part, the raising of their children, Carmen and Allyn. Being a home economics major, Hallie was a great cook and kept a well-manicured yard, where she enjoyed growing flowers and a large vegetable garden.

They lived close to school, which was convenient for Hallie, who sometimes worked as a substitute teacher. With this additional money, she paid for the furniture in their home. As Hallie was an avid painter, their walls were decorated with some of her paintings. She became involved in many community groups and functions, serving as a sort of ambassador for Roseburg Lumber and Kenneth in the community. Both Kenneth and Hallie were very driven, independent people who maintained high standards.

When Kenneth could break away (especially on Sundays), they did the fun, typical family things together. Family and education were important, and bringing home a good report card was a big deal. Carmen remembered Kenneth sitting down with her to discuss high school courses and her preparation for college. Along those same lines, Kenneth enrolled Allyn in a prep school in New Jersey after his sophomore year of high school.

A Memorable Company Christmas Party

It is interesting that in 1953, as the company was experiencing quite a growth spurt, Ginny Book and the crew would create a skit for the Christmas Party that portrayed the Roseburg Lumber company fifty years in the future.

The women of the office, Roseburg Lumber. *Photo courtesy of Verna Bailey.*

Ginny admits, "I was given the dubious honor of playing Mr. Ford. I said 'dubious' because we were all a little worried about the reaction."

In the play, they portrayed Mr. Ford buying the Simpson Logging Company. He also purchased United Airlines and shipped plywood and lumber by air. In the final scene, he purchased U.S. Plywood's entire worldwide operation. Ford and his management staff enjoyed the skit immensely. Unbeknownst to the participants, Roseburg Lumber's growth would strikingly mirror some of their seemingly outlandish projections.

9
PLYING HIS TRADE

With the changing dynamics of the timber trade, Ford recruited Cliff Pearson from the Anacortes Plywood Company in 1951. Cliff Pearson had a bachelor's of science in wood technology from the University of Washington and mastered in forestry at Yale. He had earned the reputation as an expert in wood products.

It was his expertise and experience in plywood that would bring about an immediate change in the direction of the company's focus. Ford quickly expanded its presence in southern Oregon, west into Coquille, south to Riddle and, eventually, north to Goshen. As Kenneth once proclaimed, "You can't say 'whoa' in a horse race."

Plywood and Veneer

One day Ford and Cliff Pearson were standing near the machine shop at Plant No. 1 in Dillard looking over the logs across the pond and what Pearson described as six or seven cold decks stacked to the top. Pearson suggested to Ford that if he converted that particular group of logs into plywood instead of putting it into the sawmill, he could build a whole plywood plant from the difference in profitability between the two. Ford told Pearson he was nuts and walked away.

The next day, Kenneth asked him to repeat what he had said. After Pearson's explanation, Ford looked at him and said, "Well, we don't have

Kenneth Ford (left) and Cliff Pearson (right) looking at plywood, 1959. *Photo courtesy of the Douglas County Museum.*

any choice, but we better build another plant." Within about two weeks, the bulldozers were rolling.

Cliff Pearson had been spot on, and in building his Plywood Plant No. 1 in Dillard, Kenneth was certainly moving in the right direction. Allyn

THE KENNETH FORD FAMILY LEGACY

Ford agreed: "In my opinion, getting into the plywood business was the most important step this company has ever taken. It literally made us who we are today."

When Kenneth put him in charge of plywood at Roseburg Lumber, Pearson analyzed the future markets and noticed many companies using a protein glue, which was an interior glue. With the United States building interstates and superhighways, he found a niche in exterior-grade plywood for concrete forms. Pearson explained, "I was on the ground floor in developing an adhesive with Weyerhaeuser." He eventually improved on these adhesives and obtained two patents for gluing plywood, one for softwood and another for hardwood.

Roseburg Lumber became the first major manufacturer to use all exterior glue in the making of plywood. Former employee Bill Crenshaw remembered, "Mr. Pearson had a patent on his black glue formula which was used in the production of exterior plywood…Our products were known across the U.S. for the glue bond quality of our product."

This plywood concept was further illustrated when the Stanford Research Institute reported, "In 1944, the industry's 30 mills had produced 1.4 billion square feet of plywood." By 1954, the industry had grown to 101 mills, and production approached 4 billion square feet. They then predicted that "demand for plywood would rise to 7 billion feet by 1975." However, in 1959, production had skyrocketed to almost 8 billion feet, and by 1975, production in the United States alone had exceeded over 16 billion feet.

According to Jim Pratt, "Kenneth's true passion was building things, and he often lost interest once the building process was completed." With the success of his first plywood plant, Ford built Plywood Plant No. 2 in Dillard in 1956. At the same time, a veneer plant was also constructed on a ranch he purchased from Bill Dixon. The ranch was originally bought to build a large pond for storing logs from the North Umpqua region for use in the mills during the winter.

The ranch proved to be a great location, as there was plenty of room to store the logs and it was more cost effective to peel the logs there and haul the veneer to the plywood plants in Dillard. The Douglas Veneer plant was built and run as a subsidiary of Roseburg Lumber. With two plywood plants operating, the veneer was transported by a continual flow of trucks and trailers. One trailer would be loaded with veneer in Dixonville while another full trailer would be en route to Dillard. The driver then picked up the empty trailer and returned to the Douglas Veneer plant. The process repeated itself again and again on what was dubbed "the Dixonville Trolley."

SOUTHERN OREGON TIMBER

Dixonville mill, 1960. *Photo courtesy of Allyn Ford.*

George Bryan, who began his career with Roseburg Lumber at Tyee in 1952, was the yardman in Dixonville. George lived across the road from the plant and was responsible for overseeing the entire 1,740-acre complex. Ford not only ran the veneer mill there but also maintained a working ranch with sheep, hayfields and several barns on the property. On Sunday mornings, Kenneth and Hallie often stopped by Bryan's place to buy milk and eggs.

Mac McLain began working for Roseburg Lumber at the sawmill in Dillard in 1952, during the expansion of the mills. One day while busy working at the mill, Kenneth, who was pulled in many directions, told Mac, "I've got to get Orvis [Ford] down here." Orvis was Kenneth's cousin, who, along with his dad, Bernard, worked in the Lacomb mill for Clair Ford.

During World War II, Orvis had worked at the shipyards in Portland. In addition to being part owner of a mill in Lebanon after the war, Orvis also taught welding. When he answered the call and came to work for Kenneth in 1956, he began his tenure running the truck shop. Kenneth purchased a new fleet of trucks the year he arrived.

In what was an experiment, this fleet was the first in the industry to utilize tubeless tires. The advantage was that they reduced the weight considerably, allowing the trucks to haul more pounds of timber. There was a disadvantage, Orvis explained: "We [initially] paid a price for it in flat tires over the first two years."

With his experience in the mills, Orvis soon became the superintendent over three sawmills. Charlie Matthews would replace him as superintendent of the truck shop. As his cousin Orvis explained, "He [Kenneth] treated me like any employee. I had to work harder than others, or it would be an embarrassment to him."

Expanding to Coquille

When Kenneth learned that the Textron Corporation was looking to sell its plywood plant in Coquille, he sent Cliff Pearson to look it over. Cliff spent about a week there looking over the operations and the books. The company was losing thousands of dollars each month. Upon returning, he reported to Ford that there were too many things being done wrong there—from the management to the way it ran its logs. He stated they should not buy the plant, as he didn't see how they could straighten it out. After he left the meeting, he figured the purchase would not happen. "The next thing I know, I read in the paper that he had bought it." The plant was purchased through another subsidiary of Roseburg Lumber: the Douglas Fir Division.

Coquille had quite a history of timber operations in southern Oregon. In fact, one man—George Ulett, who stood out in the forefront of this history—had not only a link to the plywood plant Ford purchased but also many similarities to Ford himself.

From Battery Separators to Plywood

While having his car battery repaired in Massachusetts, lumberman George Ulett took notice of the man replacing several thin wooden battery separators. These battery repair shops were commonplace back then, so Ulett educated himself on these separators and began to make them on his lathe, using cedar wood.

SOUTHERN OREGON TIMBER

At that time, wood had become a valuable commodity for the auto industry as a whole. A 1923 government report based on the annual output of automobiles estimated that at least 37.5 million feet of lumber were required annually to manufacture floorboards and running boards; 80 percent of the wood was softwood for running boards. The primary softwood used was the southern yellow pine. Sugar maple and ash were some of the hardwoods listed. Wood was also used for coil and battery boxes.

For his battery separators, Ulett bought cedar wood from a Kansas City wholesaler, Ralph Smith. The Port Orford cedar had become the

An advertisement with "Rosie." *Photo courtesy of Allyn Ford.*

preferred wood to use for battery separators. The geographical range of this cedar was along the southern Oregon coast. The main producer of battery separators at the time in southern Oregon was the Evans Products Company in Coos Bay.

Smith was involved in several timber outfits in southern Oregon, including two in the Hinkle Creek and Sutherlin area. In 1929, he and Ulett established a battery separator plant in Coquille, given its proximity to the Port Orford cedar. The mill became part of his Smith Wood Products Company. Smith used his business connections to secure a primary customer in the National Battery Company from St. Paul, Minnesota. Their company was an immediate success, making venetian blinds and turning out 120 million separators annually. During World War II, the WPB bought separators from both southern Oregon companies for use in military vehicles.

Since cedar does not normally grow in solid stands, the wood was harvested alongside the Douglas fir, which was the predominant tree in the area. At the time, fir timber was of little use and, therefore, very cheap. Ulett began to peel this wood and decided to try its use in plywood. In 1936, the same year Ford opened his first mill, Ulett also took a gamble, and Smith Wood Products opened the first plywood mill south of the Columbia River region. In 1946, the company sold out to the Coos Bay Lumber Company.

Ulett then organized the Coquille Plywood Company, where he served as company president. After several years, it was sold to the Textron Corporation, which quickly began losing money while operating it. As the losses mounted, Ulett advised the corporation to sell its plant in Coquille and some of its timberlands to Kenneth Ford in 1958.

Cliff Pearson spent a lot of time working to turn things around in Coquille. He oversaw the installation of new barkers, boilers and, eventually, chippers. Southern Pacific Railroad moved its tracks so the mill could be expanded. Roseburg Lumber swiftly brought the plant back to profitability, and preparations began to build another plywood plant there in 1961. Meanwhile, the company had to deal with a more pressing situation that came about in the late 1950s.

The 1957 Strike

On August 12, 1957, union lumber workers at Roseburg Lumber Company voted to strike, asking for an extra five cents per hour wage increase. This

may have been prompted by the fact that nearby Pacific Plywood had been paying an extra five cents for a couple months. The workers were represented by the Lumber and Sawmill Workers Local 2949 and the International Woodworkers of America (IWA) Local 43-436. Often these strikes were about much more under the surface than a nominal pay increase, such as working conditions, health and welfare insurance and even pensions.

A few days after the strike began, thirty employees at the Round Prairie Lumber Company went on strike in support of Roseburg Lumber. Douglas Veneer workers in Dixonville respected the picket lines, although, to the dismay of the union, they voted against the strike. As the strike gained traction, smaller mills threatened to strike if they were not granted wage increases. Several accepted a 2.5-cent increase and continued to work.

At this time, Ford, who personally handled employee grievances, was actively involved at the bargaining table. After the strike, the president of IWA stated, "When Kenneth Ford was at the bargaining table…you were dealing with a man who had the authority to make a proposal…You were eyeball to eyeball back then."

Kenneth did exert his authority and ended the thirty-seven-day strike by initiating a "five-point back-to-work offer" (which excluded a pay raise) that was accepted by the workers. Attorney Don Dole offered an interesting insight into labor issues: "If Kenneth was involved in a grievance, he could see it from the workers' side…where normally [people of his position] just held the company line."

Listening Devices

Henry Schlyper recounts a humorous story that resulted from a not-so-humorous situation. There was a time when both Plywood Plants No. 1 and No. 2 were losing "a lot" of money. Ford called an executive meeting with President John Stephens, Allyn Ford, Gary Meyers, Jim Pratt, Cal Fanus and Henry. The group arrived before Kenneth and noticed a new electronic box on the conference table, but nobody knew what it was.

When the meeting started, Henry gave the mechanical reports on the plants, followed by an operations and production report from Cal. Ford was very vocal in his displeasure in the declining numbers and called out each person individually. After a while, Henry stepped out to use the restroom, followed by Kenneth. They were standing at the urinals when Kenneth started laughing out loud.

Henry said, "Kenneth, that is not very funny what is going on in there." Ford replied, "No, it's not. But they're talking about you and me in there, and that's not very nice either!" As it ended up, the new electronic box was amplifying their conversation through Kenneth's hearing aid.

Taking Notice

People were starting to take notice of the upstart Roseburg Lumber Company and its somewhat reclusive owner. The chamber of commerce awarded Kenneth the First Citizen's award for 1958. The banquet took place at the

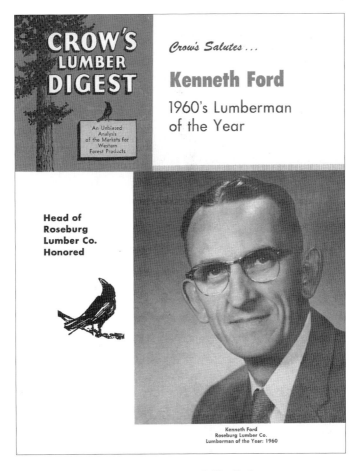

Lumberman of the Year. *Photo courtesy of Allyn Ford.*

Umpqua Hotel on January 30, 1959. Toastmaster Leroy Hiatt presented him with the honorary plaque citing Kenneth as a man "who has given of his time and energy for the benefit of our community of Roseburg to an extent that is impossible to measure." Interestingly, Ford had also made many anonymous contributions to the community over the years. He worked especially hard to ensure that area children had warm coats, hats and mittens during the winters.

In 1959, an issue of *Business Week* featured an article on Ford as "an example of one of the Northwest's bright young men." The next year, Kenneth was selected by *Crow's Lumber Digest* of Portland as the "Lumberman of the Year." This was just the beginning of many distinguished awards for Kenneth and Hallie; however, the Ford family had never been ones to revel in fanfare or accolades. Instead, they stayed committed to the job at hand: expanding business operations and helping to improve local communities.

10
CUTTING EDGE

The late 1950s brought a new wave of prosperity to the timber industry. There was a transitioning in mills as newcomers entered the marketplace. Competition was keen, with a greater move toward mill efficiency and automation. The expansion of plywood was just the beginning. In the 1960s, companies looked to expand and diversify their product lines. Lumber companies were evolving into forest product companies.

Changing Market Trends

The trick to diversity was to take the wood that was available and upgrade or change it into marketable products. In 1962, Kenneth combined the names of his two children for the name of his panel factory-finishing plant in Dillard—"Carlyn." Cliff Pearson took a tour of pre-finishing plants back East to get an understanding of the plant's requirements. Kenneth would automate almost the entire plant, utilizing what was considered low-grade white-spec logs to create a decorative panel. They produced interior wall panels in a variety of styles and species, which carried over to the more versatile indoor/outdoor T-111 panels.

During this time, many corporations were involved with consolidation and buying. Ford went outside the industry and bought a Portland-based auxiliary telephone equipment company called Code-A-Phone. This

company and its counterpart, Colonial Leasing, became part of separate unit called Ford Industries. After obtaining his master's degree from Stanford University in 1966, Allyn's first assignment was to work at Ford Industries until returning to Dillard in 1968. Code-A-Phone was sold in 1982.

The Social Pendulum Swings

Noticeable changes were beginning within America's social fabric as well. The baby boomers now represented a third of the population, and their voices became more evident. Through music and politics, their ideals were very much about being socially and environmentally conscious.

As early as 1953, the "Keep America Beautiful" campaign was being coordinated by a large consortium of American corporations and concerned citizens. This movement sought to reduce littering in America. Soon, the term "litterbug" was commonplace, and the "Pitch-In and Clean-Up America" campaign was highly publicized.

In 1965, President Lyndon Johnson passed the Highway Beautification Act, which limited billboards and other advertisements along the highways. It also called for eliminating "unsightly" messes from view along America's roadways.

It was the Wilderness Act he signed in September 1964, however, that would impact the timber industry. The act created the National Wilderness Preservation System that led to contentious debate as to the interpretation of what defined a wilderness area. The other sticking point of the act was the criteria calling for a wilderness area to be "roadless."

Air pollution became a growing concern, and clean air legislation put an end to factory smokestacks and outside burning. In an effort to abide by the changing clean air standards, Roseburg Lumber Company was one of the first in the industry to eliminate the use of wigwam burners at its facilities.

This actually occurred in concert with increasing its product mix to include particleboard, which makes use of the residual chips, sawdust and side trims from sawmills and plywood plants that were once burned. Another important feature of producing particleboard was that, in using residual wood, it was a marketable project that had a positive impact on maintaining the sustainability of timber.

THE KENNETH FORD FAMILY LEGACY

New Ventures

You're only thinking about today. It's not good enough. We've got to think twenty years into the future.
—Kenneth Ford

Particleboard was invented in Germany in the late 1940s as an alternative to plywood. Although it was not a staple yet in the American marketplace, Ford envisioned that it would become a good selling product in the future. In 1965, Ford opened a particleboard plant in Dillard that, at the time, was the largest in the United States. Despite its size and cutting-edge technology, the plant was struggling. In November 1966, Bob Crawford left Pope & Talbot out of Oakridge, Oregon, to become the third manager of the particleboard plant in just over a year.

Bob brought eight years of experience in managing a particleboard plant with him. Kenneth was aware they had problems, so he asked Bob to do a lot of observing before making changes. "One of the biggest cost

A particleboard plant, 1970s. *Photo courtesy of Johnny Parsons.*

items in manufacturing particleboard was the resin. And the resin system in this plant was not good," Bob explained. He spent a lot of time with the manufacturer's engineers analyzing it and finally convinced Kenneth to replace the original system.

When the particleboard plant was up and running well and the demand for the product increased, a second line of production was added. Crawford told a story of Kenneth at a German manufacturing company where he was purchasing a press for the plant. After receiving a set of drawings, Crawford and Kenneth flew to the factory in Germany to meet with the PhDs and engineers to discuss a very large press. Bob commented that by using his common sense and comparative judgment during these negotiations, "Ford could really turn these people inside and out by asking simple questions."

Two of the main components of the press weighed over eighty thousand pounds each. Ford didn't think the bearings they were using were big enough. However, the German engineers tried to reassure him by pointing out that they were the same bearings used on 727 airplane landing gear. Kenneth looked over at Bob and asked, "How many times a day does a 727 land?" They figured maybe two or three times. Then he asked, "How many times in twenty-four hours would you close the press?" The answer was about three hundred times. Ford found a larger bearing that would fit in the press, and the Germans reluctantly agreed to modify it for him. The press was delivered and worked very well.

About five months later, three German engineers visited Dillard, insisting that Ford be present to meet them. They said, "We have our hats in our hands. You were correct about the bearing size." The machine had failed at several plants in Germany. Interestingly, Ford used to say, "If you are not looking for trouble, you'll not see it when it occurs."

Wood Chips Division

Even with the utilization of residual wood in particleboard, Ford felt that he was not maximizing the wood chips and "cull" logs and was leaving too much timber on the ground after harvest. At the same time, postwar Japan was experiencing a shortage of wood products due to depleting forests and diminishing imports of pulp from neighboring countries like Korea. It seemed a perfect opportunity to begin a business venture. In the 1960s,

THE KENNETH FORD FAMILY LEGACY

Governor McCall's (back right) trade mission trip to Japan. Kenneth Ford is at front right. *Photo courtesy of Allyn Ford.*

however, it was tough for independent operators to enter the Japanese market on their own.

Needing to find a reliable source of chips to feed their pulp and paper mills, the Oji Paper Company out of Tokyo had originally made inroads to the United States in 1953. Their vice-president Jun'ichro Kobayashi first approached the United States about building a pulp company in Alaska to import forest products to Japan. After several meetings in Washington, D.C., the venture, which became known as the Alaska Pulp Project, was given approval by both the Interior and State Departments. With equal monetary investments from both countries, the Alaska Pulp Company was established.

A decade later, the president of the Alaskan Pulp Company contacted Kenneth about the possibility of Oji buying wood chips from Roseburg Lumber. Considering his current circumstances, Kenneth was intrigued by the idea and made several trips to Japan to discuss the venture further. Columnist and friend Gerry Pratt told that "Kenneth was fascinated with the Japanese and Asian cultures."

As they laid out the groundwork, Allyn Ford explained that the Alaskan Pulp Company worked very closely with Roseburg Lumber in the development

of its chipping operations. Ultimately, Kenneth would join Oregon governor Tom McCall's trade mission trip to Japan, and the two companies signed a contract reportedly worth $80 million. Ford returned home and built a $4 million chip-loading facility in North Bend and purchased a fleet of trucks to haul chips. On January 8, 1968, the *Oji Maru* was the first ship loaded there.

The chips business would expand quickly. Gerry Pratt revealed, "[The] first Japanese contract was for two ships to haul 5,000 units of chips a year apiece to Oji." By 1971, a contract was signed for a larger vessel to haul an additional 140,000 units. This would total 310,000 units annually for the next ten years. The facility was built with conveyors to load both soft and hardwood chips for export. In typical Ford fashion, it could be expanded to handle more chips, along with crane operations, for break bulk cargo.

The chips complemented the company's product mix well. Roseburg Lumber made use of chips from plywood operations at Dillard and Coquille. They were the first in the region to implement whole-log chippers in plants at Riddle, Dixonville and, later, Goshen and North Bend, Oregon.

These whole-log chippers had a merchandiser that removed the bark and residue and cut out an eight-foot block of wood. This salvageable piece could then be shipped for use in plywood. The low-grade pieces were then shipped to their cull wood plant in Green. This was key for the company in its uses of both high- and low-grade lumber. This concept was something that only a few places were utilizing. Allyn Ford explained, "This has refined our concept of the right log in the right place, which today can include the right veneer in the right place, especially when you add engineered wood into the mix."

Integration Application

In 1966, Roseburg Lumber Company celebrated its thirtieth year of operation. They reported selling 90 million board feet of lumber and 400 million square feet of plywood (⅜-inch basis) annually. This success, they contended, was not an accident. In looking forward, they held manufacturing and technical excellence in high regard.

Ford entered into a couple of joint ventures beginning in 1963. Roseburg Lumber Company and U.S. Plywood bought Riddle Veneer from Stomar Lumber Company. In 1965, Ford purchased it outright from U.S. Plywood. That same year, he entered into a partnership with

THE KENNETH FORD FAMILY LEGACY

Jack Brandis of Portland when they became major shareholders of the Winchester Plywood Company. They purchased the plant from Evans Products Company, which marketed a plywood product known as "Evanite." In 1967, Ford purchased another plywood plant in Green from National Plywood, which became Plywood Plant No. 3.

In March 1970, Plywood Plant No. 4 was added to the mix in Riddle. It covered seventeen and a half acres under one roof, which equated to nearly 500,000 square feet. The production goal was more than 200 million square feet (⅜-inch basis) per year. The plant employed about six hundred workers, some of whom were transferred down from the Winchester plant.

Far from random ventures, these plywood and veneer operations fit perfectly into the company's marketing plans. Each plant would specialize in separate products to meet a specific target market. The company now manufactured low and high grades of plywood. Allyn Ford noted, "We became specialty manufacturers of a commodity item. We found niches in the marketplace, latched on and [did] it well."

A good example of this is the ⅜-inch AC-grade plywood. This sanded panel of plywood was used in the soffit of older houses across the United States, and Roseburg Lumber became a leading manufacturer of it—another way they made things fit well together while creating product diversity.

11
RUN OF THE MILL

For Dad, his whole life was work, [and] he was proud of what he did. He wanted to do the best. He was a very bright, brilliant man.
—*Carmen Ford Phillips*

On Kenneth's office wall hung a plaque that read, "The world owes you a living. But you have to work hard to collect." Kenneth was legendary in his work ethic. He normally worked twelve or more hours, often seven days a week. His sleep patterns were somewhat intermittent. Ford kept a notebook on his bedside stand to jot down important ideas or concerns of the mills. If the matters were too pressing, he was known to show up at the mills in the middle of the night to check things out.

Ford did not manage the operations from behind a desk. He was a hands-on manager who originally set aside at least one day per week to peruse his woodlands operations. He had a radio inside his car to keep up on the truckers and listen to other dialogue being broadcast throughout the company.

He also spent ample time in the mills analyzing their production. He loved to get down to the floor and talk with millwrights, electricians or workers on the green chain, seeking their opinions on how things were going.

Kenneth didn't have time for idle conversation, as he routinely had too much on his agenda. Ginny Book attested to that: "If he was heading down the hall [and you needed to talk to him], you had better talk loud and fast because he was heading someplace." Most people who knew him would

concur that Kenneth often seemed hurried, and therefore it is not surprising that he drove fast as well. Some of the stories shared by his employees who rode in the car while Kenneth was driving were legendary.

Driving with Mr. Ford

Lee Williams recalled, "Mr. Ford often took me out with him to look over a new site. I felt I would just as soon ride in a plane as to ride with Mr. Ford in the green Olds, which was named 'the green hornet.' But we always made it."

In the early 1990s, there was a bad ice storm in northern Oregon. That same evening, Henry Schlyper received a call from Kenneth to meet him at 7:15 a.m. the next morning for a trip to Portland. He assumed, because of the bad road conditions, they would be taking the plane. His assumption was incorrect. Kenneth arrived in his Mercedes and reassuringly said, "Henry, most people do not know how to drive on ice; come on, get in!" North of Sutherlin, Interstate 5 was covered with a solid sheet of ice. While most traffic was creeping at ten to fifteen miles per hour, Ford, who felt confident in his four studded snow tires, quickly set the cruise control to seventy-five miles per hour. There was ice hanging from the trees and guardrails, and people were shaking their fists as the Mercedes whisked past. The farther north they drove, the worse the conditions were.

When they pulled over in Albany, Henry advised Kenneth to stay in the car, as it was nearly impossible to walk on the ice. After the stop, Henry explained, "Kenneth fish-tailed the car back onto the freeway and set the cruise back to seventy-five." When they arrived at Coe Manufacturing at 10:15 a.m., Fred Fields was astonished that they had driven the entire way, as most of his employees had failed to even make it into work.

Speeding does, however, have its limitations. Roseburg attorney Don Dole told that with Ford's heavy foot and distinctive car, every state patrolman in the vicinity recognized him. One morning, he received a call from Kenneth saying that, without warning, a police officer had come to the Dillard mill and taken away his driver's license. Ford had accumulated too many tickets and had been ordered to attend a driver's improvement class, but he had failed to attend. "You and [Al] Flegel have to get my license back. I've got things to do!" Ford demanded.

Flegel was a state senator at the time, and between him and Dole, they managed to get his license back. Dole suggested, "It was based on a lot

of promises that he would attend the driver's improvement school." When Dole contacted the state police office, the officers said they knew Ford would get the license back so they had just placed it in a drawer. They promptly delivered it back to him. "Kenneth was not the kind of person to flaunt the law. If he didn't have his license he would not have driven," said Dole.

Did the driver's license apprehension and driver's improvement class make a difference in Ford's driving? Frank Buell humorously recalled, "Kenneth and I would go to the coast a lot, and he liked to push that Mercedes. I didn't like it, and I would tell him. He would say, 'Well, I am driving.' One day on the way to Coquille, I asked him to let me drive, and he agreed." As they approached Coquille, much to Buell's chagrin, Ford looked him in the eyes and said, "Frank, you are just making me sick the way you drive!" After work, Frank took the driver's seat but only got as far as Myrtle Point when Kenneth said, "Frank, I am going to have to drive." Within minutes, the Mercedes was again cruising down the road toward Roseburg at eighty miles per hour.

Time Flies

Friend Rick Watkins was driving Kenneth home from an auction one evening when they began discussing the uses and practicality of e-mail and the Internet, which had recently been installed at the mill. Rick thought this new technology might be helpful to Kenneth in his business communications. Rick offered to teach him how use e-mail. Kenneth was not at all interested. When Rick asked why he didn't want to learn, Kenneth replied, "Because you have one luxury that I don't have." Given that Kenneth was one of the wealthiest men Rick knew, he was dumbfounded as to what luxury he might possess that Kenneth didn't have. Kenneth answered, "You have the luxury of having time. I don't have the time to learn e-mail or the Internet."

Management Style

Kenneth had a reputation as being a tough guy to work for. There was not much fraternization with employees, as most conversations were directed toward work-related issues. New management hires normally learned each job from the ground up before being elevated to their management position.

Ford kept a close eye on new employees until they proved their merit. Allyn Ford said, "He broke every management rule in the book. He was always driving, but it worked, as there was little turnover. There were no pats on the back. You had to know him well to pick up subtle hints [compliments] or he would give you a certain job to do that increased your authority."

Along the same lines, according to Jack Snodgrass, Kenneth showed appreciation by allowing employees to manage their aspects of the business a lot more independently, more than other companies would have allowed. "That was the reward. It was to have the freedom to be your own person."

Friend and fellow businessman Jerry Bruce explained that, outside the mill, Kenneth was quiet: "You hardly knew he was there." However, once inside the mill, Kenneth was on his turf. In his car, Kenneth carried a hard "safety" hat and a pair of coveralls. He also carried a tablet, several felt pens and a ruler. Ford was the only one allowed to use a red felt pen in the mills, which became his signature way to communicate to managers. He also used these pens to indicate his observations and often changes to blueprints.

Ford seemed to manage more on instinct than on theory. Philosophically, he held high expectations. He demanded a lot of his workers, but he was fair. There were many stories of Kenneth's dealings with day-to-day operations and challenges that offered interesting insights into his style of management.

The Firing Line

One evening around 7:00 p.m., plywood manager Jim Pratt got a phone call from concerned workers at Plant No. 1 in Dillard. Kenneth was out back firing a gun into the wall of a building. He had recently rebuilt an older shed, and no one had understood why, thinking maybe it was for some sort of storage. When Pratt arrived, Ford had several hunting rifles and was blasting away at the building's concrete foundation. Pratt asked, "Kenneth, what are you doing?" At first Kenneth didn't answer and continued shooting the rifle. Pratt continued to question him until Ford said, "Do you really want to know?" Pratt replied, "Well the whole damn mill wants to know… and I need to explain to them that this is rational."

Ford was preparing to put a tower and shed on the summit of Mount Scott, and he was worried that people might be up there shooting guns around the building. He wanted to make sure the building could withstand it.

SOUTHERN OREGON TIMBER

Barnyard Engineering

When visitors or salesmen would come to the mill looking for "Mr. Ford," he would often be identified as the man in the dirty, greasy coveralls or simply pointed out in a group of workers as the dirtiest one in the bunch. But it was his knowledge and willingness to jump in and work in the trenches that earned him a great deal of respect from not only his employees but his peers as well.

Stub Stewart, owner of the Bohemia Lumber Company, had an appointment to meet Ford at 9:00 a.m. on a Saturday at the Winchester plant to discuss a timber issue. Upon arrival, he was told that Kenneth would be a bit late, as he was working on something near the millpond. Stub recalled, "When Kenneth arrived, he was covered in mud from head to toe with a saw in his hand. He was always on the job twenty-four hours a day, 365 days a year."

When there was a grievance by union employees over pay and working conditions in the boiler room at a Dillard sawmill, Mac McLain explained that Kenneth brought his lunch with him and went over there and worked shifts with the guys there so he'd know exactly what they were experiencing.

Kenneth liked to bounce ideas off others to gain better insights into upcoming projects. Jim Pratt said, "You didn't have to talk to Kenneth Ford very long before you understood he had a brilliant mind…He automatically sucked all the information out of you, just like a vampire. He had a network [of people] on any subject."

Johnny Parsons brought a lot of construction experience to Roseburg Lumber in 1971 when he was hired as superintendent of the carpentry shop. One of his early projects was to build an office at Plant No. 3 in Green. Kenneth was known for not following plans and blueprints to the tee, and often changes were indicated with his red pen. Parsons said, "It got to where we weren't comfortable using a set of plans if there was no red ink on it. We figured maybe Kenneth hadn't looked it over yet."

When they built the office in Green, there were no plans drawn up yet. Ford simply told Parsons to go from the corner of the building and line it up with a telephone pole alongside the road. He explained the approximate size of the building he wanted and left them to their devices. Parsons recalled that the engineering department was calling him for the measurements of the building because they were drawing up the blueprints while the office was being built.

Orvis Ford remembered that Kenneth wasn't afraid to admit something was wrong and tear it down and do it over. Ford once removed a new, entirely built wall at a plant in order to move it over four inches. In one instance,

Blueprint plans with Kenneth's signature ink. *Photo courtesy of Bob Crawford.*

Ford instituted what he called "barnyard engineering." With the original blueprints out the window, the construction crew wasn't certain on the dimensions between the toilet stalls in the restroom. Ford arrived, squatted down extending his arms outward and said, "Measure between my elbows, and add two inches for clearance." Problem solved.

Frustrated Engineers

When it comes to organizing and handling machinery, Ford's the best nut tightener in the business.
—George French, U.S. Plywood

Jim Pratt explained, "We would go to Coe [Manufacturing] and tell them what we wanted, and Fred Fields would say this is the machine we want to sell you. We would say, 'No, that isn't the machine we want to buy,' and we'd make them change the machine for us. They hated it, but then they would turn around and sell that same [improved] machine to everyone else, and it became the standard of the industry."

SOUTHERN OREGON TIMBER

In his biography, Fields said that when Ford purchased equipment, "He wanted to know every nut and bolt and every bearing, the type of bearing and every minute detail of all the machinery…And by the time he got it up and running…he was the best second guesser in the world. He'd find all sorts of reasons why the darn thing didn't work as he envisioned it."

Kenneth had spare parts scattered about his operations on what were referred to as bone yards. These piles contained parts for most every piece of equipment he owned. His employees marveled at how well he knew where and in which pile a needed part was located. To keep parts available, he often attended local auctions.

Auctioneer Al Lewis said, "Ford's mere presence at an auction commanded respect." It also started to bring the prices higher, so Ford would ask Jerry Bruce to go to the auctions for him. One of the first times Bruce was sent to buy a specific piece of equipment, he called Ford from the auction: "Kenneth, you never told me how much money I should spend on this." To which Kenneth replied, "I didn't tell you how much to pay for it, I told you to buy it!" Another time, Ford had placed items on the auction block that mistakenly included a piece he didn't want to sell, so Bruce was sent there to buy it back.

Milling Around

There were many interesting stories from the mills of southern Oregon as to what made this area unique. Industry insider Rod Greene pointed out that when the term "timber industry" is used, it is in broad terms. There is a huge difference between large conglomerates that are not from the area and the local family-owned businesses.

He stated that local owners "live here, work here, invest here and care about here. For large conglomerates from out of state, a factory here is [often] just a bottom-line number." The local owners had always been tough competitors. They bid hard against each other. But when the sales were over, they went out and worked together to aid in community projects, putting their differences aside.

Woolley Enterprises was a large timber employer in Drain. It owned and operated local timber mills—the Smith River Lumber Company and the Drain Plywood Corporation—employing over three hundred workers. It eventually partnered with Stub Stewart in operating the Mount Baldy Lumber Company in Yoncalla.

THE KENNETH FORD FAMILY LEGACY

For many, Harold and Donna Woolley will be remembered for their love of baseball. In the early 1950s, they brought baseball to Drain when they sponsored the Drain Black Sox. The team recruited top college and amateur players who were hired to work at the mill, but in reality they mainly played baseball. After compiling a 54-4 record in 1958, they went on to win the National Baseball Congress Tournament in Wichita, Kansas.

In 1950, Sun Studs Incorporated moved into Roseburg on old Highway 99 South. Although owner Fred Sohn and Kenneth Ford were friends and had great respect for each other, they were known to be fierce competitors. Like Kenneth, Sohn gave back to the community and assisted in establishing St. Joseph's Church and the Community Cancer Center, as well as relocating Mercy Hospital to its new campus.

In business, Sohn worked diligently to stay on the cutting edge of computerization in his plants. According to historian Larry Moulton, "In 1972, they had the only computerized sawmill in the world." The Sun Studs mill was sold to Swanson. Lone Rock Resources managed approximately 125,000 acres of the timberlands. Fred passed away on July 22, 2011, at the age of ninety-six.

In 1954, Norman Jacobson and Richard Adams purchased the old Sutherlin Plywood Plant. They combined their names and came up with Nordic Plywood. In 1958, they bought Perkins Veneer in Roseburg. A couple years later, the partnership was dissolved, with Adams becoming sole owner. Upon Richard Adams's death, his sons, Bob and Art, purchased the company from the estate. Bob retired in 2008, and Art continues to manage Nordic Veneer, Inc. in Roseburg.

With other competing mill owners, such as Dan Keller, Francis Engle (Cottage Grove), Milt Herbert, Sid Leiken, Paul Hult, D.R. Johnson, Bud Johnson, Sid Comfort and Maurice Hallmark, the area surrounding Roseburg, Oregon, was referred to as a "hornet's nest." But it was the competition that helped make everybody better.

12
OUT ON A LIMB

In 1976, the country's bicentennial year, Kenneth Ford was reflecting on Roseburg Lumber Company's fortieth year in business: "The past forty years have been good to us, and we look with anticipation to the challenges of the future."

The company bought out Hult Lumber Company in Dillard, adding Sawmill No. 2. A large new truck shop was built while the mills were being refurbished as they transitioned to the trend of processing smaller logs. To outsiders, it appeared to be business as usual; however, Kenneth's personal life shifted as he and Hallie divorced. After over thirty-five years of marriage, they had simply grown apart. Journalist Gerry Pratt said, "They were both great people. The two were very much alike, yet they walked on different sides of the street."

Hallie moved to Salem; Kenneth rented an apartment in Roseburg and had a place in Portland that was more convenient for conducting business with his accountants and other associates located there. Always on the go, Kenneth was also doing more international travel with his expanding global business interests.

ADDITIONS

Roseburg Lumber attributed its continued success to "highly efficient manufacturing and maximum resource utilization." By the mid-1970s,

the company had recruited Bill Whelan from U.S. Plywood in Eugene as its vice-president of production. As assistant to the president, Allyn Ford gravitated to the resources side of the company. Thus, together, they could orchestrate their focus and adapt quickly to the changing environment of the industry. And big changes were coming soon.

Kenneth Ford surprised the industry with the purchase of Kimberly Clark Corporation. In addition to sawmills, his company purchased 323,000 acres of timberland for $253 million, outbidding Simpson Timber Company for the corporation. As *Newsweek* magazine said, "[He] set the industry on its ear."

Bonnie and Kenneth Ford, La Quinta, California. *Photo courtesy of Bonnie Ford.*

SOUTHERN OREGON TIMBER

This purchase was a considerable amount of money, but the company felt it was necessary. The writing was on the wall, as the old standby of government timber was getting more costly. This additional timberland would require a lot of cleaning up and planting, but it filled in a big gap in their long-term timber sustainability.

On November 20, 1982, Kenneth and Bonnie Stanley were married in Portland, Oregon. She said that Kenneth had been a "fleeting acquaintance" when she worked as a dietician at the Douglas Community Hospital. After she moved to Las Vegas, Kenneth would come down for industry conventions, and they eventually began a relationship. Kenneth's turf was in the mill, however. Bonnie stated, "He knew when he stepped in the door, the home was my turf."

Bonnie was very involved with the community and received the Chamber of Commerce First Citizen Award in 1990. Most workers and friends noticed that Kenneth was much more mellowed and relaxed after marrying Bonnie. She added additional years of happiness to his life. Bonnie encouraged Kenneth to get out into the community more often. She also planned many international vacations, including a trip around the world on the *Concorde*. She was very supportive of the Ford Family Foundation and instantly bonded with the Ford Scholars.

SHIFTING GEARS

In 1982, Ford brought in John Stephens from the International Paper Company as president and CEO while he remained as board chairman. The company continued fine-tuning its operations, including a Melamine line in Dillard that offered another value-added product. In 1985, Roseburg Forest Products and RLC Fibre Industries were founded. However, the company was bogged down with the high interest rate on the $253 million loan for Kimberly Clark. To make matters worse, it had financed this illiquid asset at a variable rate. These timberlands offered no immediate timber to harvest that could be used to help pay down the loan. This debt debacle was coupled with the policies of the Federal Reserve chairman Paul Volcker, who was dealing with inflation and then stagflation in the marketplace.

To combat inflation, Volcker raised the federal fund rate of interest from 11.2 percent in 1979 to an astounding 20 percent in 1981. The high

interest rates caused the economy to tank. This hurt the price of timber and affected the contracts timber companies had signed on very high-priced government timber. Allyn Ford recalls, "We had a tremendous amount of government timber, and the value of those timber sales absolutely collapsed. This created a terrific challenge."

Had companies been forced to process this timber, they all could have conceivably gone broke. Many companies were on the brink of bankruptcy. So a conference was held in Reno with industry leaders. Kenneth Ford gave a memorable speech stating, "I will have blood running out of the soles of my shoes when I can operate those contracts."

The industry sued the government, which led to a 1983 "buyback" legislation allowing companies to return up to 200 million board feet of government timber sales. (President Ronald Reagan remarked on this in his book, *The Reagan Diaries*.) Roseburg Lumber Company had considerably more timber than that, so Allyn said that they hunkered down and pumped up production at their mills, buying low-cost timber, as well, to soften the blow with dollar-cost averaging.

In 1986, the company was fifty years old with approximately four thousand employees. CFO Ron Parker was hired that year, during this tumultuous time. Kenneth was known for his ability to thrive on adversity, and the company showed its resiliency when it purchased the Paul Bunyan Lumber Company that same year. Two years later, it made another California acquisition obtaining a sawmill, plywood mill and 235,000 acres from the Diamond Lands Corporation.

However, during this time, the company got word that its bank would no longer extend credit over $5 million, effectively parting ways with Roseburg Lumber. Before bank mergers, this bank was originally a hometown bank that had stuck with Ford in the early years when he was still struggling to make ends meet.

Parker explained that they opened up an account with a new bank, but Kenneth was reluctant to sign the signature card. So Parker kept transferring funds into the old account to write the checks. After several attempts, Ford was still not interested in signing the card. Finally, Ron explained to him, "We are out of checks and this is no longer our bank, we need to move on." Ford replied, "Get the plane ready." And with that he was heading to Portland to talk with the head of the original bank.

Unannounced, Ford arrived at the bank office where the CEO's receptionist called him out of a meeting to see Kenneth. The bank officer might have thought he was in for a good chewing out, but when

he reached the lobby, Kenneth shook his hand and thanked him and the bank for fifty years of support. In a display of integrity, he didn't want to end the relationship without a handshake. Back in Roseburg, he signed the signature card.

1987 Strike

The 1987 strike was far more encompassing than that of 1957. It was unique in that the workers weren't seeking a pay raise. They were striking to avert a cut in pay. In mid-December 1986, Kenneth Ford outlined a contract to his 4,300 union employees that he stated would help the company keep the mills running and compete within the industry.

Ford proposed a four-year deal that called for immediate wage cuts ranging from $1.25 to $1.65 per hour. According to the *News Review*, "The proposal would then provide a $1,400 signing bonus the first year and increase wages by a total of 11 percent over the remaining three years of the contract." Both the Lumber and Sawmill Local 2949 and the IWA Local 43-436 unions agreed that "the wage reductions are unacceptable." They agreed they would negotiate until January 4, but without a settlement at that time, a legal impasse would be declared.

With no settlement reached, the strike officially began on January 11, 1987. Negotiations broke down as both sides dug in for the long haul. Always the visionary, Kenneth used the time to revamp and update his mills. Some union employees crossed the picket lines and ran a scaled-down production in the mills. Others were sent down to work in the non-striking northern California mills.

The tensions ran high with rhetoric from both sides stating their opinions. Ford even received threats, but in his normal style, he maintained his composure. CFO Ron Parker recalled that he was driving to the office after a meeting in town when he heard a local radio commentator. "He was just ripping Mr. Ford, talking about the terrible injustice that was being done to the workers and their families. He called Ford evil and greedy."

Parker stated that this was a radio station that Roseburg Forest Products (RFP) regularly supported, within its policy of giving back to the community. Quite upset by this, Ron talked to Kenneth about calling the station manager and cutting off support for the station. Kenneth's

response speaks volumes. "People's emotions are running high in a circumstance like this. Don't get upset by this. After the strike, it will settle down and things will return to normal."

The strike was costly to both sides. Parker estimated the company lost about $10 million per month, which equates to a staggering $40 million during the four-month strike. Workers lost much-needed wages during that time as well. Even if one side got everything it wanted, they could still not earn back the lost revenues.

Ford published a nine-page letter to the workers, again explaining that companies in the industry like Georgia Pacific had taken pay cuts, giving them a competitive advantage over RFP. On May 18, the strike officially ended with both sides making myriad concessions on issues such as hourly pay, overtime pay on Sunday and vacation pay—and it was back to work.

13
TRANSITIONING

By the end of the decade, the companies that withstood the crises during the mid-1980s were now gaining traction. The availability of foreign markets for wood products increased their bottom lines and provided a hedge against future economic downturns. The National Forest Products Association projected exports to nearly triple from their lows of 1985. However, there was yet another battle for the industry on the horizon.

The Spotted Owl Controversy

The spotted owl controversy would become a paramount battle in what had been an ongoing struggle waged between the timber industry and environmentalists. The owl, which stands about eighteen inches tall, has an average life span in the wild of around ten years. With its numbers dwindling, the spotted owl was listed as a threatened species from Washington to northern California.

The debate centered primarily on the harvesting of old-growth trees, as this owl served as an indicator species representing the health of old-growth forests as a part of the entire ecosystem. However, a 1991 lawsuit requiring the designation of "critical habitat for the spotted owl" would have a far more reaching impact than simply placing it on the threatened species list.

THE KENNETH FORD FAMILY LEGACY

This battle would change the ground rules for future legislation and how future legal battles would be fought.

The two sides became further entrenched in the fight of how much habitat was needed to support a breeding pair of owls. Environmentalists claimed that it required 2,200 acres. The timber industry supported science that showed much less acreage was required.

President Bill Clinton's 1994 Northwest Forest Plan was initially drafted to protect wildlife habitat. It became much more, including a series of stringent guidelines for land use on federal lands in the Northwest. It also called for a decrease in timber yields within the National Forests.

A Paper Trail

With a timber supply crunch, there were widespread mill closures. According to Oregon State University statistics, the number of sawmills in Oregon decreased by 56 percent between 1980 and 1997. Plywood and veneer plants dropped by 62

Roseburg Lumber Company reunion. *Photo courtesy of Johnny Parsons.*

percent. Employment in the timber industry declined by over 30 percent as well. The headlines in area papers bid farewell to mills and a way of life in Oregon.

After 107 years, the Simpson Paper Company was closing its mill in West Linn with 388 jobs lost. In Bend, Crown Pacific Ltd. closed its mill, putting 90 people out of work. In what Stub Stewart called a "margin squeeze," production was halted at Bohemia's Culp Creek plywood mill, indefinitely laying off 225 workers.

In 1992, Kenneth Ford went public, stating that his business was for sale. He entertained about fifty potential buyers, but the business was soon taken off the market. In the end, the company sold some of its northern California properties to Red Emmerson's Sierra Pacific Industries. With these proceeds, Kenneth sold out his shares in the company. Kenneth continued as chairman of the board while using the proceeds from the sale to launch his next phase of the Ford Family Foundation. Hallie's shares were eventually bought out as she continued her philanthropic endeavors as well.

Community Building

In the late 1940s, Kenneth saw a need for additional hospital facilities in Roseburg. Ford became very active in a fundraising campaign, establishing the Douglas Community Foundation for the sole purpose of funding a hospital. Ford donated $50,000 to launch his support of the project. He also served as the chairman of the building committee, traveling around the country looking at various hospitals to then formulate a workable plan out of some eighteen different floor plans. He donated the time and company equipment needed during the construction phase. The Douglas Community Hospital was dedicated on February 11, 1951.

The hospital ran as a nonprofit organization until it sold in 1986 to a for-profit corporation. With no feasible way to give proceeds back to its original donors, the Douglas Community Foundation took on a new role of making grants to support a broad range of community projects. This foundation was eventually merged into the Oregon Community Foundation.

For Hallie and Kenneth Ford, giving to people or communities in need was simply a core value. They preferred to give anonymously without seeking fanfare. In 1957, the couple established the Kenneth W. Ford Foundation, which consisted of a checkbook they kept in the top drawer of a desk at the office. They found a variety of ways to give back to the community.

THE KENNETH FORD FAMILY LEGACY

Lending a Hand

Shelley Briggs-Loosley summed it up: "When Kenneth Ford made a commitment to a project, he wanted to know that the community was 100 percent behind it. By showing commitment, the community had to generate additional funds to support his generous contributions."

Shelley explained that, in 1995, Ford offered to accept ownership in a joint project at the YMCA to embark on a pool and a new facility. When the community showed its support by raising $500,000, Ford contributed $2.8 million to the project.

When the county needed a new library, Kenneth worked with them through his friend and local businessman Jerry Bruce. Judge Randy Garrison stated that Kenneth's offer to match funds had a resounding impact on the library. Donors were excited to see the fund growing, which helped efforts substantially.

Douglas County commissioner Doug Robertson worked with Jerry on the library building plans. Jerry coached Robertson that Ford would want to know the particulars of the library before committing the funds. Bruce told him, "Kenneth cares about the books, but he really cares about the building."

Doug thought he had a good grasp of the building plans when he met with Kenneth. However, Ford grilled him on every aspect of the building from the footers and frames to the carpeting. He made modifications on several important aspects of the building and then donated the funds. In the end, he would give much more than his initial commitment. In November 1994, the library was officially dedicated.

Ford also donated money to numerous other projects, including infrared hearing devices at the Oregon Shakespeare Festival. He moved the historic Dillard O&C Railroad depot to the Douglas County Museum. Trent Drake, a Douglas High School student, was raising funds to attend a wrestling program. "We needed 'x' number of dollars, so I picked a few places hoping to get $100 from each one to make my goal. Kenneth talked to me for about forty minutes in his office, then had Carol [McLaughlin] issue me a check." When Trent opened the envelope, the check had covered the entire amount Trent needed for the program.

Attention to Detail

In 1996, the company bought International Paper's Oregon timberlands. Allyn said, "We paid too much, but we had to do it." With more than 200,000 acres,

SOUTHERN OREGON TIMBER

Harry Merlo World Forestry Award. *Photo courtesy of Allyn Ford.*

the company had assured an uninterrupted supply of future timber. This would be the last major timber purchase in which Kenneth was involved.

In that same year, Kenneth was the first recipient of the Harry Merlo Award. This World Forestry award was to honor outstanding individuals who had made a lifetime commitment to the dedication of forest management.

Electrician Perry Murray said that Kenneth called him at home on a Friday night in January 1997. This, he said, was not common but at the same time was not unusual. Ford asked Perry to meet him in the morning in Dillard. When Perry asked what he should bring, Kenneth replied, "Bring your ingenuity." Perry had a good idea what work he needed done, and since he had heard that Ford was sick and going to the Mayo Clinic for treatments, Perry decided to arrive an hour early. When he arrived, Kenneth was already there and asked him to work on a machine that advanced railcars for unloading.

Murray explained, "He had [the] plans with him, but [he] was having trouble staying focused—this was considerably different [from his norm]." Murray had done work for Kenneth since 1974, when Ford purchased the Paul Hult Lumber Company mill in Dillard. Later that day, they went to the office, and he asked Kenneth, "Mr. Ford, are you sick?" Kenneth replied, "They know what is wrong, but they don't know what they are

going to do about it." Not wanting to put him through any more strain, Perry left, assuring him that "we'll make it work." Although the thought crossed his mind to give Kenneth a hug before leaving, he didn't. It is something he still regrets. A few days later, Kenneth was admitted to the hospital and passed soon after that. Kenneth had stayed busy tending to his mills right up to the end.

Kenneth passed away on February 8, 1997. Over seven hundred people from all walks of life paid their last respects to Ford at St. Joseph's Catholic Church. Over the years, he had touched many lives. Kenneth built his first mill in 1936 when he was twenty-eight years old. In his last days, he was still focused on the company. Not only did he work with Perry Murray, but he was also revising plans for a new stud mill in Dillard. The *News Review* remembered him as a man who lived the American dream and carried with him a community on his shoulders.

> *People have been so good to me that I want to give back to them. This company, the timber industry, my friends and family, and the employees are the ones who will carry on when I am gone. You are now the torch bearers, and you must understand your responsibility to mankind.*
> —Kenneth Webster Ford

Coming Full Circle

One of the early logging camps for Kenneth Ford was in the Hinkle Creek area in the late 1930s. Seventy years later, Allyn Ford set aside 4,534 acres for the Hinkle Creek Paired Watershed Study with Oregon State University. This watershed study allows scientists to determine the effects on streams where forests are being harvested versus the baseline area that remains untouched.

They are looking at the effects on fish, amphibians and aquatic invertebrates. The study also tracks how the chemistry of the streams and nutrients in the soil are impacted by logging. Former BLM manager Bob Alverts, who has spent a career as a forester, explained, "Results are providing key new science information that will be useful…in the application of the Oregon Forest Practices Act rules." The Hinkle Creek study is one of three watershed studies being performed in western Oregon.

SOUTHERN OREGON TIMBER

The Spirit Lives On

Kenneth had a long-term plan for this company, and I intend to see his vision completed.
—Allyn Ford

Shortly after Kenneth's death came the planned closing of the veneer plant in Dixonville. In addition to upgrading its other plants, the company built an Engineered Wood Products plant in Riddle. This modern plant, which covers eleven acres, was engineered to accommodate growth without obstructing the integrity of the existing structure. The company continues to look for growth in value-added wood products that utilize the entire log of various species. What started as a single sawmill in Roseburg has become a company that today operates plants throughout the United States.

On September 15, 2014, a small grass fire near Boles Creek, east of the town of Weed, California, soon became a raging wildfire. Flames, propelled by forty-mile-per-hour winds, quickly descended on the town, forcing over 1,500 residents of the area to flee with only minutes to spare. The Roseburg Forest Products workers voluntarily stayed and fought the fire at the mill, some knowing their own homes were in peril.

The company's immediate response and resolve clearly displayed the spirit of Kenneth Ford. Grady Mulbery, vice-president of operations, said, "Our objective…is to provide stability to the community as quickly as possible." Workers who lost their homes were placed in temporary housing. Some of the workers were moved to plants in Oregon while others stayed on in Weed to help rebuild the plant. Every effort was made to help them earn a paycheck in this disaster. A matching fund was set up by the company, and Oregon employees pitched in over $51,000 to help the families rebuild. Roseburg-area residents also collected supplies to deliver to Weed. Though Kenneth Ford passed away in 1997, his spirit is still clearly evident today.

14
A FIRM FOUNDATION

In 1975, as incoming president of Linfield College, Charlie Walker was committed to meeting with all fifty trustees of the college. This led him to Dillard to meet with Kenneth Ford. This meeting was the beginning of a long-lasting friendship and productive working relationship. Although Kenneth never attended a single board meeting during Charlie's seventeen-year tenure, he was always willing to help whenever Charlie asked him.

A reluctant public speaker, Ford rose to the occasion at Charlie's retirement party in 1992. Before leaving the Benson Hotel in Portland that night, Kenneth said to Charlie, "Don't ever let anyone put their thumb inside your belt without talking to me." Soon, Charlie would answer Kenneth's call for assistance in developing a more dynamic charitable foundation from the small fund he and Hallie had created in 1957.

Through continual dialogue, the two exchanged ideas to clearly identify and define goals and procedures in establishing the governance of the foundation. Kenneth also communicated with other foundations to gain information and ideas. After further deliberation, they were ready to begin the project with a "pilot" program, offering scholarships to students based on need.

SOUTHERN OREGON TIMBER

Winging It

In 1994, they launched their flagship program and had their first class of forty-three Ford Scholars. Kenneth wanted the initial meeting to be at an elegant place, so the recipients, spouses and parents were invited for dinner at the Benson Hotel. At the urging of Charlie, Kenneth gave a speech to the scholars and had his picture taken with each student. In the speech, he said, "I didn't give you money. I invested in you, and I expect a return on my investment."

Walker remembered, "The response was very compelling with a feeling of gratitude." As the people shook Kenneth's hand, "I think for him that was the moment to feel his dream was okay." He could see that through this foundation, he could give the students an opportunity he didn't have.

Kenneth kept up on the students' grades and sent out letters every term on various topics of interest for the scholars. In the summer, he held a three-day retreat at Salishan Resort. Ford formed a close bond with the students; if they sat on the floor, he sat on the floor. "I think it was a terrific satisfaction for him to see these [scholars] beginning to see they were very special," Walker recalled.

In 1996, sixteen members of the first class graduated and decided to perform a makeshift cap and gown ceremony. Each scholar took the microphone and told their personal story and how the scholarship had changed their lives. As a single mom of three young children, Andrea Smith was just trying to make a better life for her family.

She later wrote, "Among us sat a humble man whose own dream made these feats possible. And he had tears streaming down his face, as did everyone there (even the servers!). Yes he paid our way through school, but far more importantly, he believed in us and made each one of us feel like we could accomplish just about anything…He was tremendously proud of each one of us." Kenneth passed away the next year. Many scholars, like Andrea, attended the funeral.

The Ford Family Foundation

In June 1996, the articles of incorporation were changed, bringing the official name of the Ford Family Foundation. Attorney Norm Smith began his tenure as the foundation president near the time of Kenneth's

death. As the foundation was run out of Roseburg Forest Products' Dillard office, his office consisted of a metal desk and filing cabinet in a room on the second floor.

Kenneth Ford had a reputation for surrounding himself with good people, and he left an extremely capable board of directors to carry on his foundation. Norm's first order of business was to establish a strategic plan for implementing the core values and vision of the foundation. The directors consisted of Chairman Ron Parker, Charlie Walker, Allyn Ford, Sally McCracken, Jerry Bruce and Joe Kearns. Shortly thereafter, Carmen Ford came aboard.

The group came together to establish which values were important to both Kenneth and Hallie. If a value wasn't representative of both of their wishes, it was tabled. The foundation identified five core values: Integrity, Stewardship, Respect, Independence and Community. Its mission is to foster "Successful Citizens and Vital Rural Communities."

There are four unique scholarships. The initial program was the Ford Scholars. The foundation also offers the Ford ReStart, Ford Opportunity and Ford Sons and Daughters scholarships. Each program serves a special niche. In addition to educational scholarships, the foundation is actively involved with communities and economic development.

Friends Donna and Rick Watkins remembered how proud Ford was of his students. He had fond memories of the time he spent with them. Ford felt the leadership training and encouragement the foundation provided was just as important as the funding.

Hallie established the Ford Opportunity Program in 1996. Education was important to Hallie, and she understood the extra responsibilities of a single parent in obtaining a college degree. She also felt that by helping the parent, this would improve the child's future as well. She was the first in her family to finish high school and go on to college.

At East Central University, Hallie could not afford to live in the dormitory. Instead, she lived with a large family where she worked cooking, cleaning and caring for their children in their home, all the while attending to her studies. Many felt this lifestyle would be difficult to maintain for four years; however, Hallie was able to graduate in just three! Hallie had a contagious smile as, years later, she proudly recalled that during her time in college, she never missed a single football game.

SOUTHERN OREGON TIMBER

Ford Scholars Give Back

From her childhood growing up in the small town of Junction City, Oregon, Charity Dean dreamed of being a doctor. Requiring more than her determination to make college a reality, she applied for general scholarships. She admitted, "I knew nothing about the Ford Family Foundation since it was only in its second year…I showed up at the interview clueless about what it really was." When the acceptance letter arrived from the foundation, she and her mother read in disbelief as it explained the scholarship would pay 90 percent of the costs for college.

Charity Dean and Kenneth Ford. *Photo courtesy of Charity Dean.*

THE KENNETH FORD FAMILY LEGACY

She was off to a tough start in college when she attended Ford's funeral, and the gravity of what being a Ford Scholar meant sank in. She turned things around quickly and finished at the top of her class. The foundation continued its support of Charity as she worked to complete a master's in public health along with her medical degree at Tulane University. Charity currently serves as the physician health officer with the Santa Barbara County Public Health Department. She also helped write healthcare legislation that was signed into law in California.

Growing up in Tennessee, Johnny Lake learned a couple of lessons in life at an early age. He was taught the merits of hard work, and in fifth

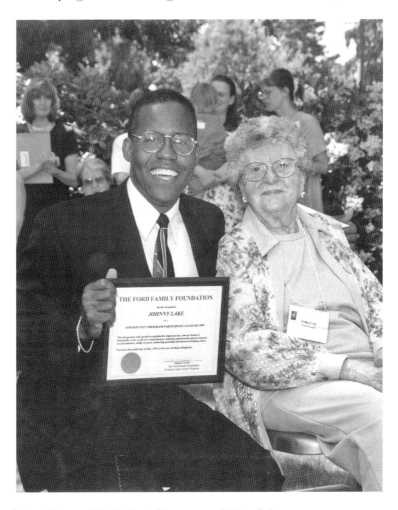

Johnny Lake and Hallie Ford. *Photo courtesy of Johnny Lake.*

grade, he learned how to deal with diversity when his mother took advantage of volunteer integration in schools. Johnny was the only African American in his class at school. He excelled in his studies, but when he graduated, he faced a tough decision. He had to choose between going to college and working with his father laying bricks. Since his family was not well off, he chose to work.

Johnny later found himself living in Oregon, a divorced single parent with four children. To make ends meet, he worked two jobs, one of which was as a driver for Federal Express. He spent his lunch breaks at a school working with children. The school superintendent took notice of his abilities and encouraged him to consider a career in teaching. Johnny initially took classes at Chemketa Community College and excelled there. A Ford Opportunity Scholarship helped him to get a bachelor's degree in history from Willamette University. The scholarship allowed him to go on to get a master's degree and a PhD in educational leadership at the University of Oregon. He has since taught a variety of programs as a professor at Northwest Christian University in Eugene. And recently he published a children's book aimed at dealing with diversity and putting a stop to bullying.

Although Kenneth and Hallie were divorced, they never lost sight of their core values and the desire to help others. They worked both together and separately in their philanthropic endeavors over the years. They never sought recognition for their generosity; in fact, they were almost embarrassed by any public accolades.

Today, foundation president Anne Kubisch and her dedicated staff seek out new avenues in an ever-changing environment to broaden the foundation's reach in helping individuals and communities while maintaining the integrity of the Fords' legacy.

15
SUSTAINABLE YIELDS

The glory days of logging where sawmills were abuzz and served as landmarks in city centers has passed. Stewart Holbrook stated, "Even the useful term 'skid road' has been corrupted in many places and turns up in the press and conversations as 'skid row.'" The tall tales of the mighty Paul Bunyan seem to have lost their relevance today. They've all but faded away, along with the glowing embers of the loggers' campfires, which in time have turned black and cold.

In the past decades, lawsuits and tighter government regulations have drastically reduced logging in southern Oregon. This has caused numerous mills to shut down, taking with them thousands of jobs. Competition has also increased worldwide. The companies of today have embraced these challenges by improving their efficiencies while finding practical uses for entire logs.

The sophistication of machinery and computerized equipment has opened up the need of a new skill set for workers. Roseburg Forests Products plant manager Dave Lowry said, "We have a state-of-the-art facility here, the best technology and the best equipment, but it's the people who make this facility world class."

Through innovation and automation, companies are also producing more marketable wood-products from a variety of tree species and residual wood. This enables them to maintain sustainable yields while decreasing the footprint of logging on the environment.

SOUTHERN OREGON TIMBER

The remnants of old logging camps remain throughout southern Oregon, although the trees are in the process of reclaiming these lands that were once theirs. Throughout all the progress in the timber industry, one constant has remained steadfast throughout time: the resilient forest.

BIBLIOGRAPHY

Abdil, George B., ed. *The Umpqua Trapper*. Vol. 9. Roseburg, OR: Douglas County Historical Society, 1973.
"Action on Car Shortage in Willamette Valley." *St. Louis Timberman* 18, no. 11 (1917): 32.
Alanen, Donald Matthew. *The Logger's Encyclopedia: A Road to the Past*. Baltimore: Publish America, 2008.
Andrews, Ralph W. *Glory Days of Logging*. New York: Bonanza Books, 1956.
———. *Timber*. West Chester, PA: Schiffer Publishing Ltd., 1984.
Bakken, Lavola J. *Land of the North Umpquas*. Grants Pass, OR: Te-Cum-Tom Publications, 1973.
———. *Lone Rock Free State*. Myrtle Creek, OR: Mail Printers, 1970.
Beckham, Curt. *Early Coos County Loggers*. Myrtle Point, OR: Hillside Book Co., n.d.
———. *Gyppo Logging Days*. Myrtle Point, OR: Hillside Book Co., 1978.
Beckham, Stephen Dow. *Land of the Umpqua: A History of Douglas County, Oregon*. Roseburg, OR: Commissioners of Douglas County, Oregon, 1986.
———. *Swift Flows the River*. Coos Bay, OR: Arago Books, 1990.
Beebe, Sandra. *The Company by the Bay*. Springfield, OR: By the Bay Press, 1988.
Beuter, J.H. *Legacy and Promise: Oregon's Forests and Wood Products Industry*. Revised and updated. Portland, OR: Oregon Forest Resources Institute, 1998.
Brier, Howard M. *Sawdust Empire: The Pacific Northwest*. New York: Alfred A. Knopf, Inc., 1958.

BIBLIOGRAPHY

Brinkley, Douglas, ed. *The Reagan Diaries*. New York: Harper Collins Publishers, 2007.

Burkhardt, D.C. Jesse. *Backwoods Railroads*. Pullman: Washington State University Press, 1994.

Cartwright, Marvin. *I'd Still Be a Logger*. Klamath Falls, OR: Graphic Press, 1999.

Conant, Luther. *The Lumber Industry*. Parts 2–3. Washington, D.C.: Government Printing Office, 1914.

Connelley, William E. "Biography of Robert Alexander Long." A Standard History of Kansas and Kansans. http://www.ksgenweb.com/archives/1918ks/biol/longra.html (accessed January 2015).

Cox, Herbert J. *Random Lengths*. Eugene, OR: H.J. Cox, 1949.

Creighton, Jeff. *Logging Trucks, Tractors, and Crawlers*. Osceola, WI: Motorbooks International Publishers & Wholesalers, 1997.

Edmonds, Michael. *Out of the Northwoods: The Many Lives of Paul Bunyan*. Madison: Wisconsin Historical Society Press, 2009.

Fields, Fred. *My Time with Coe: Free Enterprise at Its Finest*. Montgomery, AL: Donnell Group, 2010.

"General News." *St. Louis Timberman* 58, no. 7 (1816): 78.

Gintzler, A.S. *Rough & Ready Loggers*. Santa Fe, NM: John Muir Publications, 1994.

Goodwin, Ted. *Stories of Western Loggers*. Chehalis, WA: Loggers World, Inc., 1977.

Greeley, W.B. "The American Lumberjack in France." *American Forestry* 25, no. 306 (1919): 1093–1108.

Griffiths, Morgan. *Sawmill Modeling*. Corte Madera, CA: Paradise Publishers, 1998.

Guyer, R.J. *Douglas County Chronicles*. Charleston, SC: The History Press, 2013.

Hagenstein, William D. *Corks & Suspenders: Memoir of an Early Forester*. Eugene, OR: Giustina Land & Timber Co., 2010.

"History of Longview, Washington." http://www.ci.longview.wa.us/community/longview_history.html (accessed November 2014).

Holbrook, Stewart. *Holy Old Mackinaw: A Natural History of the American Lumberjack*. Sausalito, CA: Comstock Editions, 1980.

Hubbard, Doris Winter. *Widow-Makers & Rhododendrons*. Central Point, OR: Hellgate Press, 2000.

"Iowa Capitalist Interested in Lumber Road." *Lumber Manufacturer and Dealer* 54 (1914): 41.

BIBLIOGRAPHY

Lewis, Richard. "Tree Farming: A Voluntary Conservation." *Journal of Forest History* (July 1981): 166–69.

"Month's Review of Mill and Camp Activities." *St. Louis Timberman* 19, no. 8 (1918): 49–50.

Moulton, Larry. *History of Douglas County Sawmills*. Roseburg, OR: self-published, 2002.

Perkins, Nelson S. *Plywood in Retrospect: Smith Wood Products, Inc*. Tacoma, WA: Plywood Pioneers Association, 1976.

Rajala, Richard A. *Clearcutting the Pacific Rain Forest: Production, Science and Regulation*. Vancouver: University of British Columbia Press, 1998.

Robbins, William G. *Hard Times in Paradise: Coos Bay, Oregon*. Seattle: University of Washington Press, 2006.

———. "The Social Context of Forestry: The Pacific Northwest in the Twentieth Century." *Western Historical Quarterly* 16, no. 4 (1985): 413–27.

Rohde, Patricia A., and E. Lorraine Potter. *Gardiner, Oregon, 1850–2000*. Gardiner, OR: Gardiner Odd Fellows #132, IOOF, 2001.

Scott, Doug. *The Enduring Wilderness: Protecting Our Natural Heritage Through the Wilderness Act*. Golden, CO: Fulcrum Publishing, 2004.

Stevens, James. *Timber! The Way of Life in the Lumber Camps*. Evanston, IL: Row, Peterson and Co., 1942.

"Timeline Library." http://www.historylink.org/index.cfm?DisplayPage=output.cfm&file_id=10692 (accessed July 2104).

Turner, James Morton. *The Promise of Wilderness: American Environmental Politics since 1964*. Seattle: University of Washington Press, 2012.

Waddle, Susan. "West Fork in the Cow Creek Canyon." *Pioneer Days in the South Umpqua Valley* 43 (2010): 12–30.

Webber, Bert, and Margie Webber. *This Is Logging and Sawmilling*. Medford, OR: Webb Research Group Publishers, 1996.

INDEX

A

Adams, Art 131
Aydelott, Herman 82, 83, 100

B

blacksmith 32
Booth-Kelly Lumber Company 33, 57
Brewster, Oregon 60, 82
Buell, Frank 126

C

Chicago World's Fair 68
chute 31, 81
Coos Bay, Oregon 23, 39, 113
Coquille, Oregon 111
Crawford, Bob 119

D

Dillard, Oregon 78, 93
Dolbeer, John 31
Douglas Veneer 109
Drain, Oregon 27, 130

E

Evans Products Company 113

F

flume 27, 80
Ford Family Foundation 146
Ford Lumber Company 69
Ford Scholars 146, 148

G

Gardiner Mill Company 23, 36
Green, Oregon 128
gyppo 44

H

Hinkle Creek 76, 95, 143

J

Jewett, Wilson 39

K

Keller, Dan 98

INDEX

L
Leiken, Sidney 99, 131
Leiken, Thora 99
Long-Bell Lumber Company 42

M
McLain, Mac 110

N
Nordic Veneer 131
North Bend, Oregon 122

O
Oregon and California Railroad
 Company 22, 95
owl, spotted 138

P
Parker, Ron 135, 147
Pinchot, Gifford 48
Powers, Albert 39
power saws 96
Pratt, Jim 127, 129

R
Riddle, Oregon 122
Roach Timber Company 95
Roseburg Lumber Company 70
Roseburg, Oregon 63, 74

S
Schlyper, Henry 114, 125
skid road 19, 28, 151
Smith, C.A. 39
Snodgrass, Jack 103
Sohn, Fred 131
Sutherlin, Oregon 97

T
Tyee Forest Cooperative 99

U
Ulett, George 111
U.S. Forest Service 48

W
Walker, Charlie 145
Weed, California 43
Wendling, Oregon 33, 57
West Fork, Oregon 80
Weyerhaeuser, Frederick 41
whipsaw 34
wood chips 120

Y
Young's Bay Lumber Company 91

ABOUT THE AUTHOR

R.J. Guyer is a freelance writer from Roseburg, Oregon. He authored *Douglas County Chronicles: History from the Land of One Hundred Valleys* in 2013. He is a regular contributor as a columnist to the *News Review*. His writing has also been featured in other newspapers and magazines. He has a passion for history and is a member of the Douglas County Museum. Originally from Napoleon, Ohio, he received a bachelor's degree in finance from Emporia State University in Kansas.

Visit us at
www.historypress.net

This title is also available as an e-book